30100000105640

DATE DUE			

DISCARD

COLORADO
portrait of a state

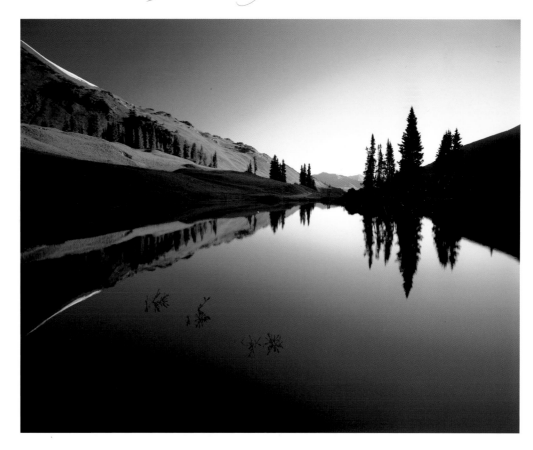

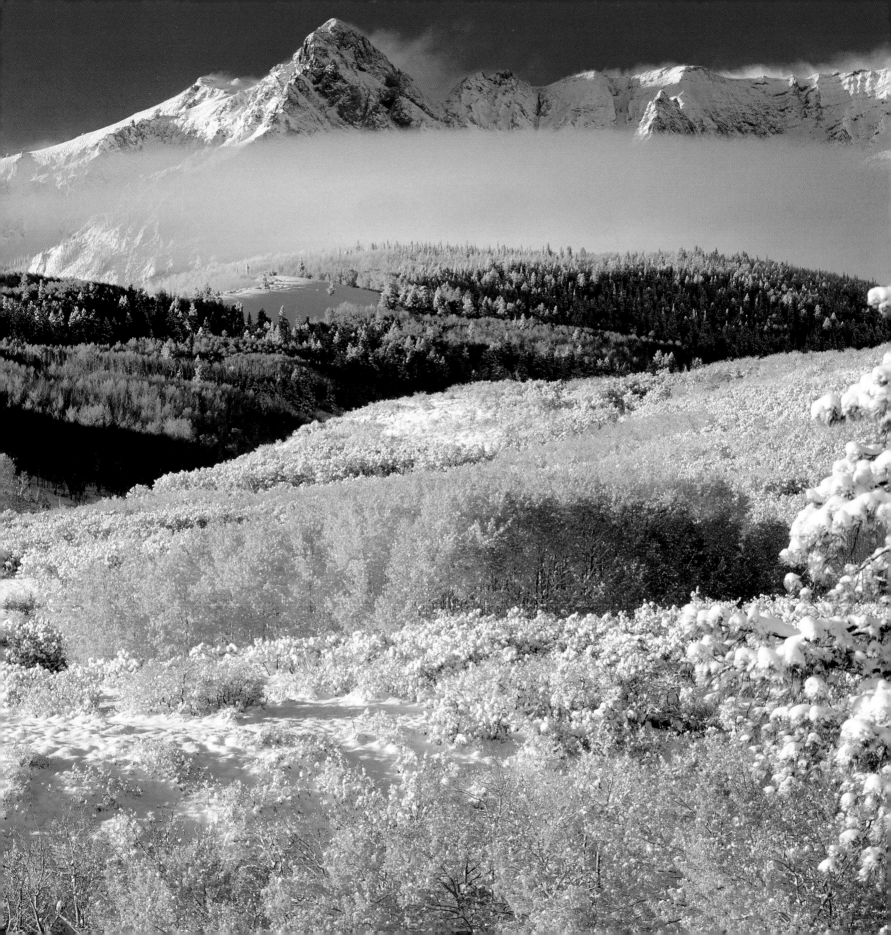

COLORADO

portrait of a state

DAVID MUENCH • MARC MUENCH

GRAPHIC ARTS BOOKS

Library of Congress Control Number: 2004103694
International Standard Book Number: 1-55868-847-1

Graphic Arts Books, an imprint of
Graphic Arts Center Publishing Company
P.O. Box 10306, Portland, Oregon 97296-0306
503/226-2402; www.gacpc.com

President: Charles M. Hopkins
Associate Publisher: Douglas A. Pfeiffer
Editorial Staff: Timothy W. Frew, Tricia Brown, Kathy Howard, Jean Bond-Slaughter
Production Staff: Richard L. Owsiany, Heather Doornink
Cover Design: Elizabeth Watson
Interior Design: Jean Andrews
Cartographer: Ortellius Design

Printed in China

◄ ◄ A Paradise Basin pond, at about 11,000 feet, holds crystal-clear reflections.
◄ Mount Hayden, elevation 12,987, rises above rolls of fog and aspen
in the Sneffels Range of the Uncompahgre National Forest.

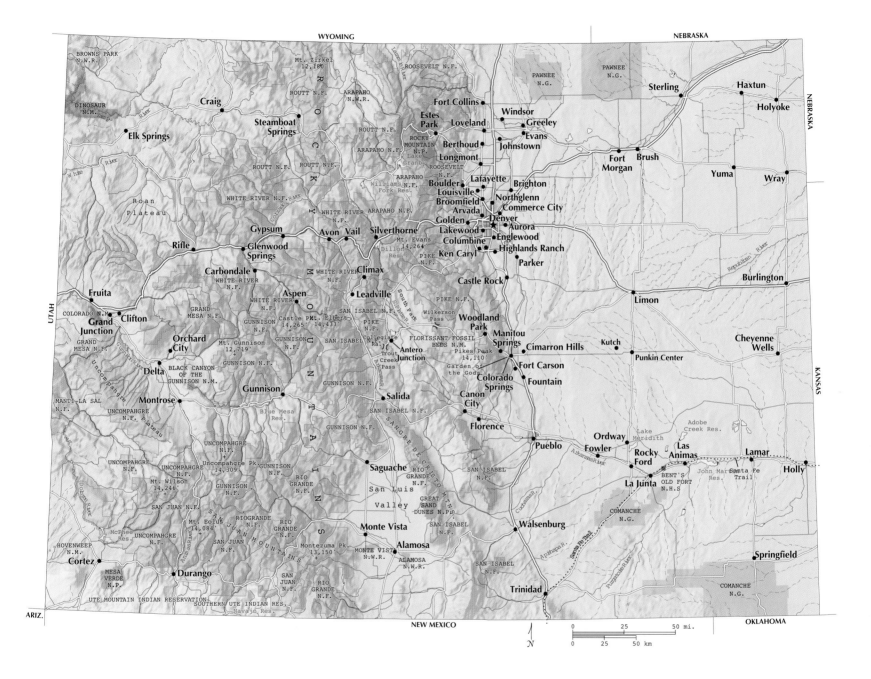

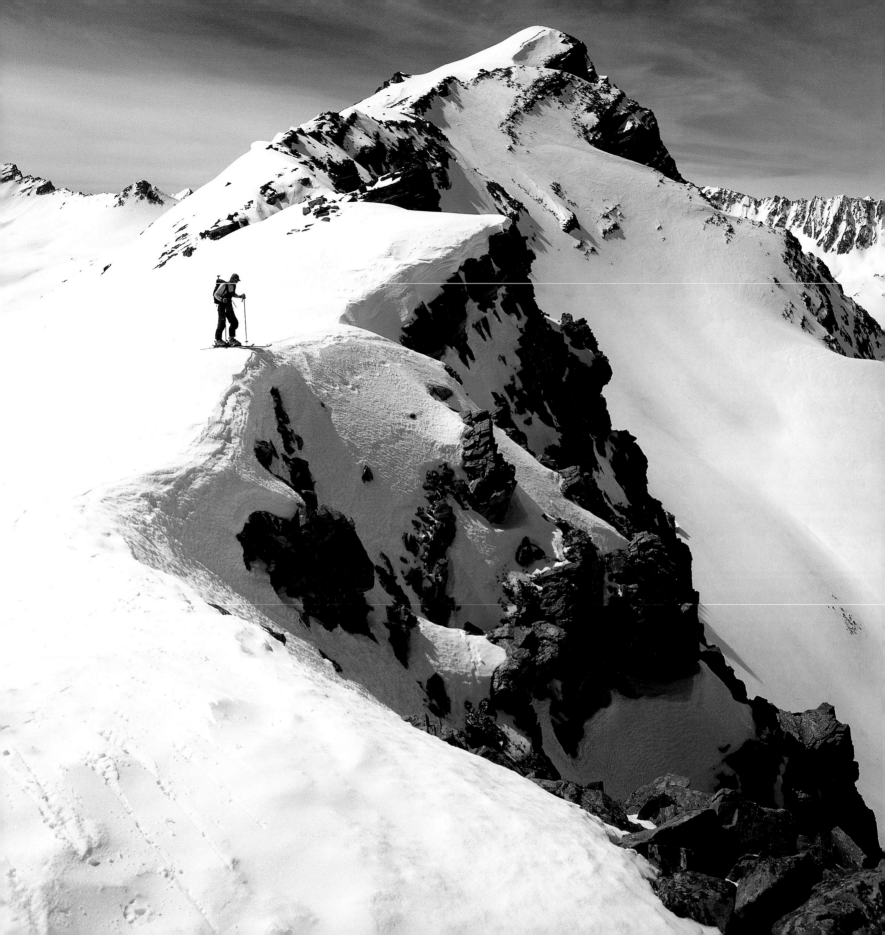

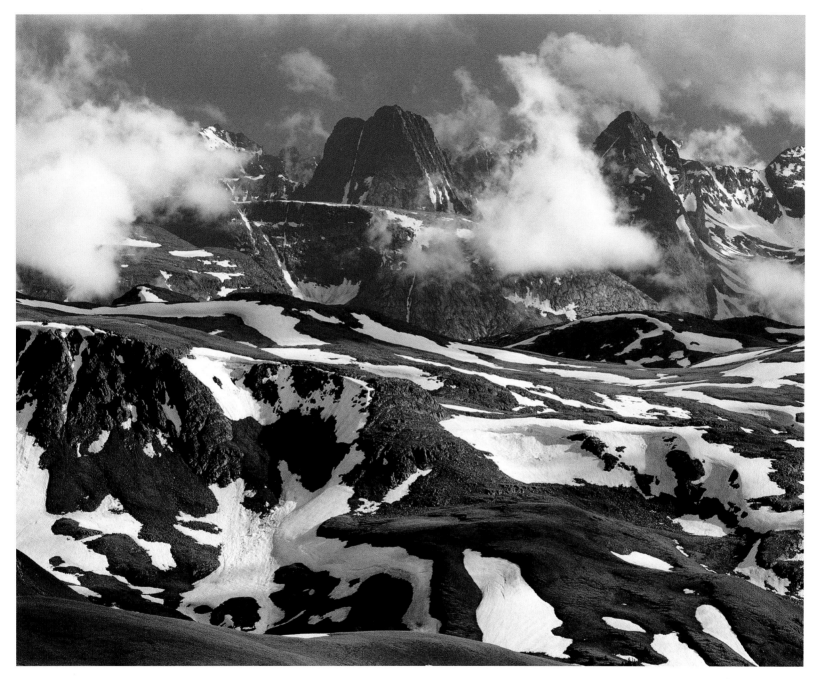

◄ A grand view and a quick ski down are the rewards for an arduous ascent up to
13,000 feet on a ridge between Conundrum Basin and East Maroon Canyon.
▲ Clearing storm clouds reveal the high peaks of the Grenadier Range.

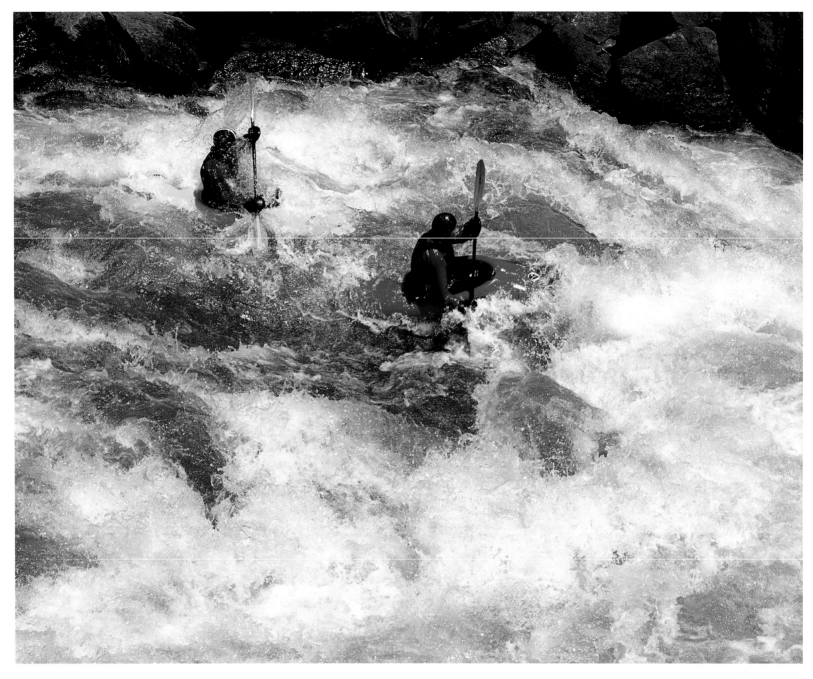

▲ Kayakers run the rapids in Cache la Poudre River,
which has been designated a National Wild and Scenic River.
▶ Pastel hues color a metamorphic rock design high above a cas-
cade that rushes through narrows of the upper Cache la
Poudre River in Roosevelt National Forest.

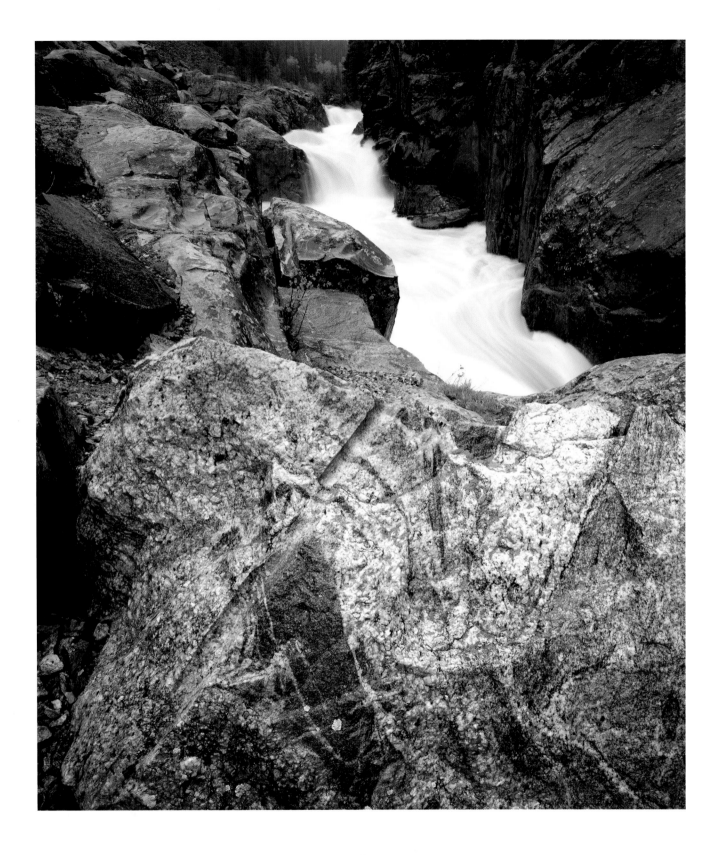

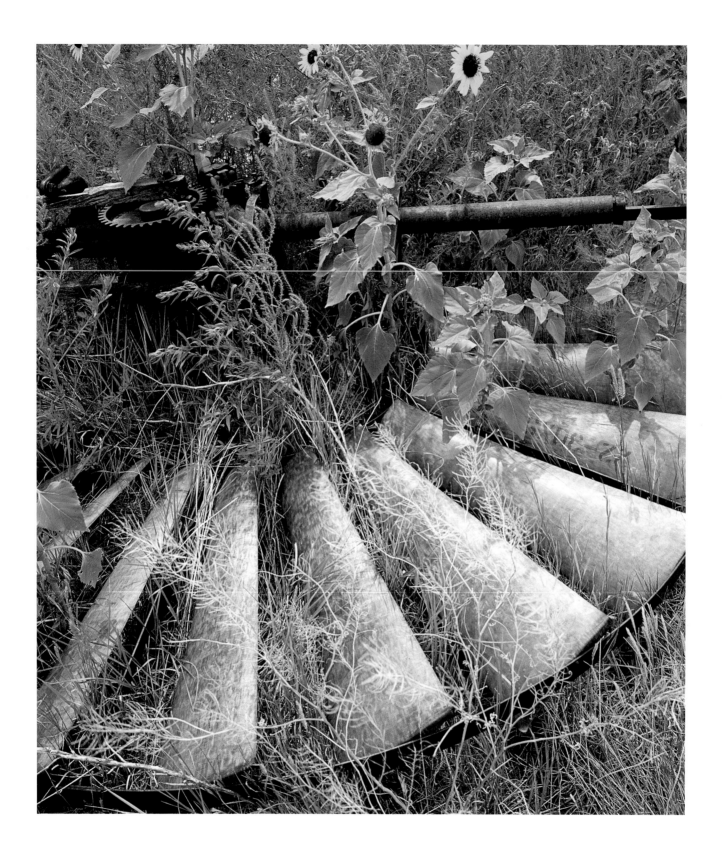

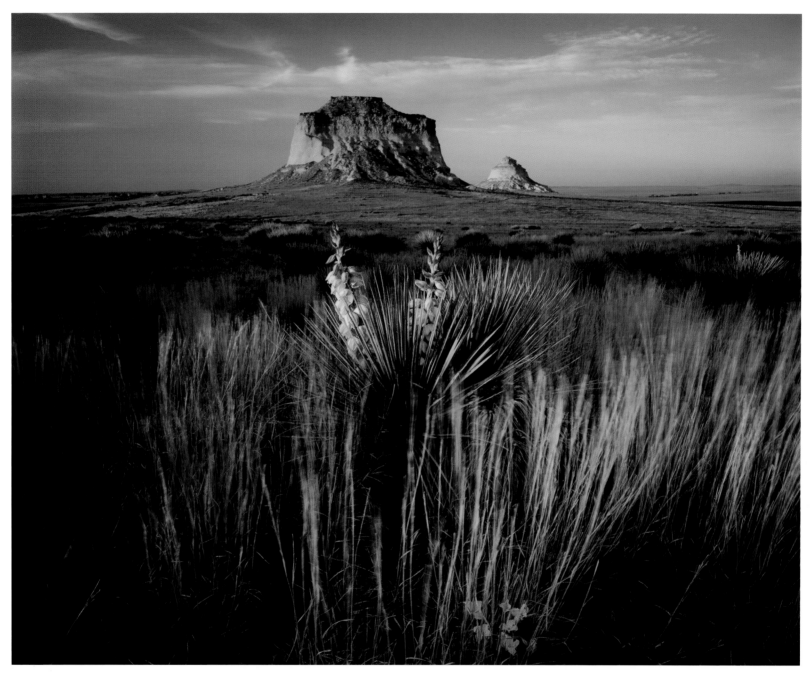

◄ Blades of a fallen windmill become quickly
overgrown with sunflowers and grasses near the town of Raymer.
▲ Pawnee Buttes rise above windblown soapweed yucca *(Yucca glauca)*, primrose, and grass.
► ► A windmill is silhouetted against a dusk glow over the
Pawnee National Grasslands.

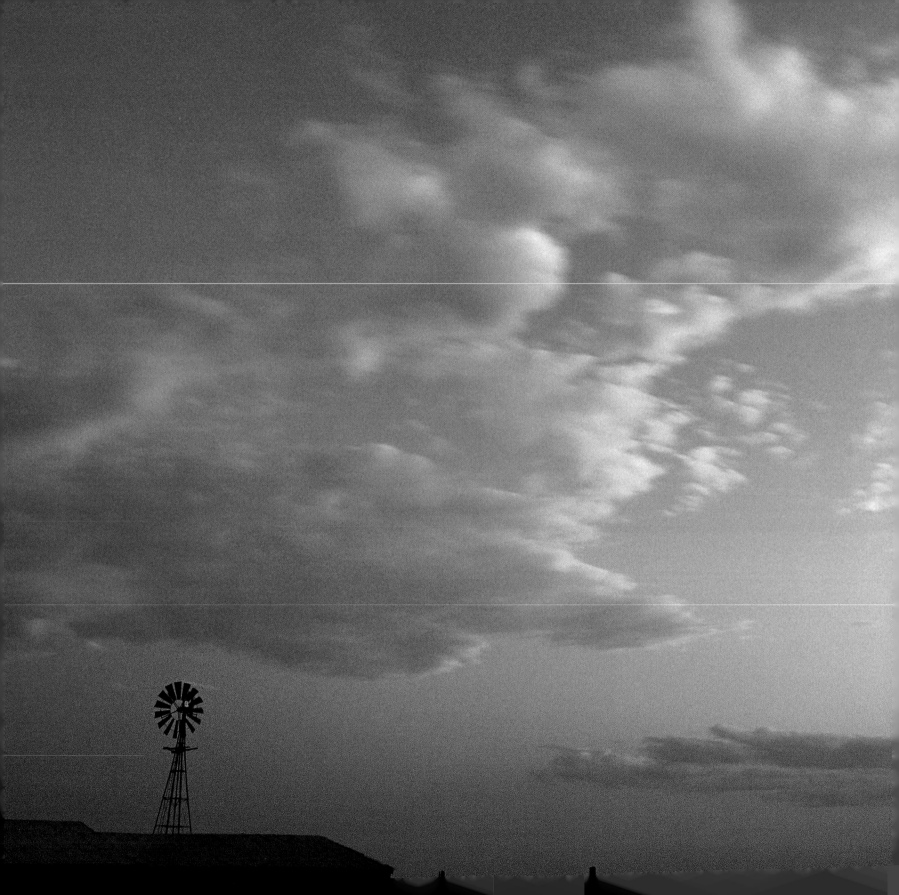

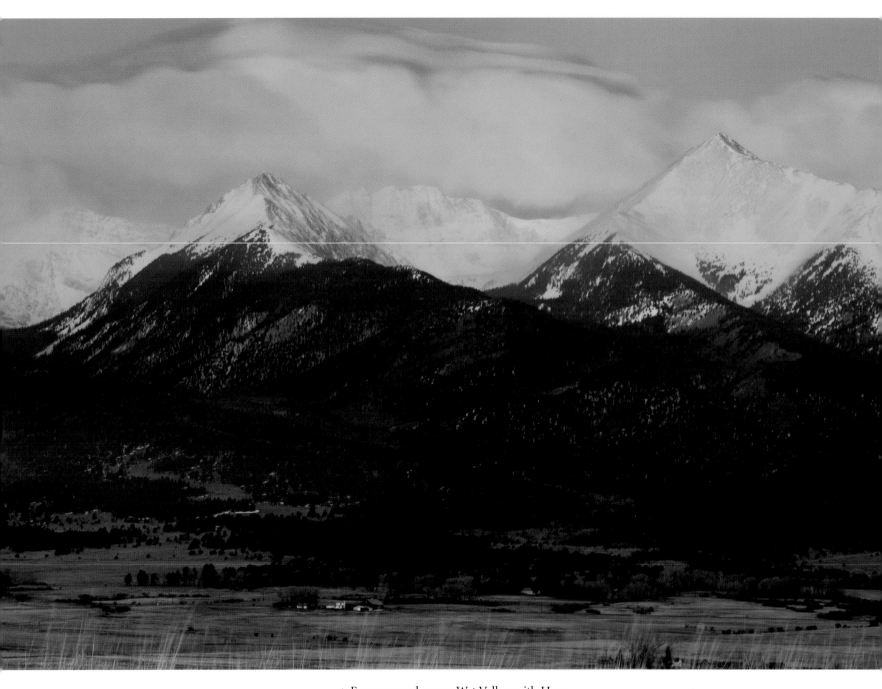

▲ Farms sprawl across Wet Valley, with Horn
Peak of the Sangre de Cristo Range looming above.
▶ Spring brings multiple hues of green to an aspen grove in
Maroon Canyon in White River National Forest.

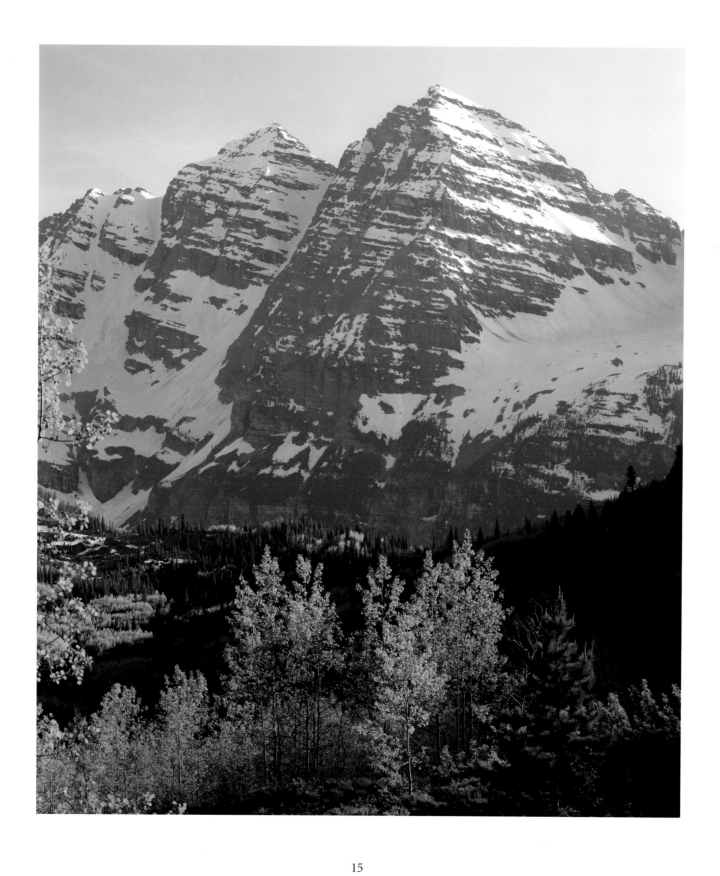

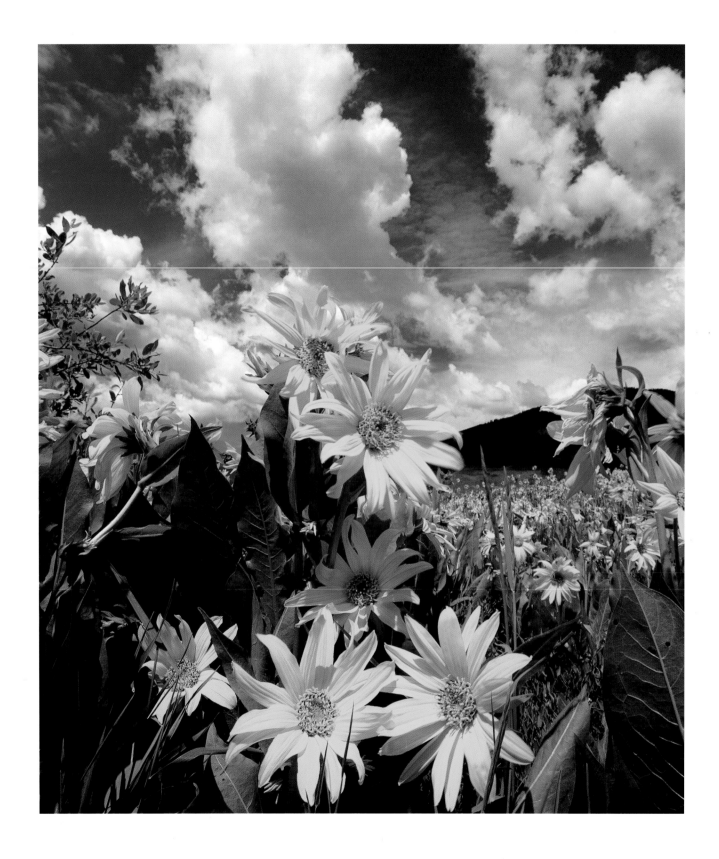

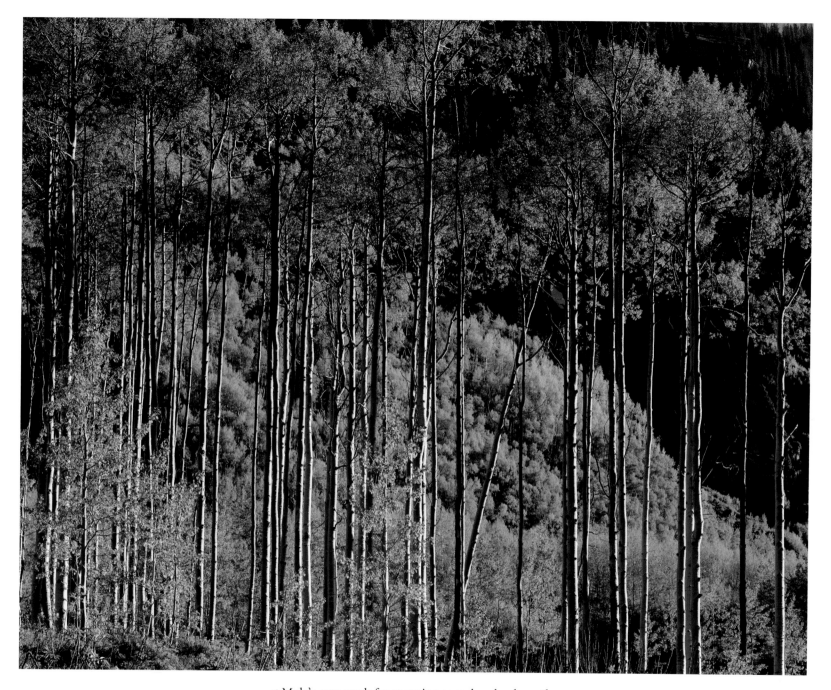

◄ Mule's-ears reach for morning cumulus clouds on the
slopes of Snodgrass Mountain in Gunnison National Forest.
▲ Shades of green herald the advent of spring in an aspen grove
situated at the base of 14,156-foot Maroon Peak, in the
Elk Mountains, White River National Forest.

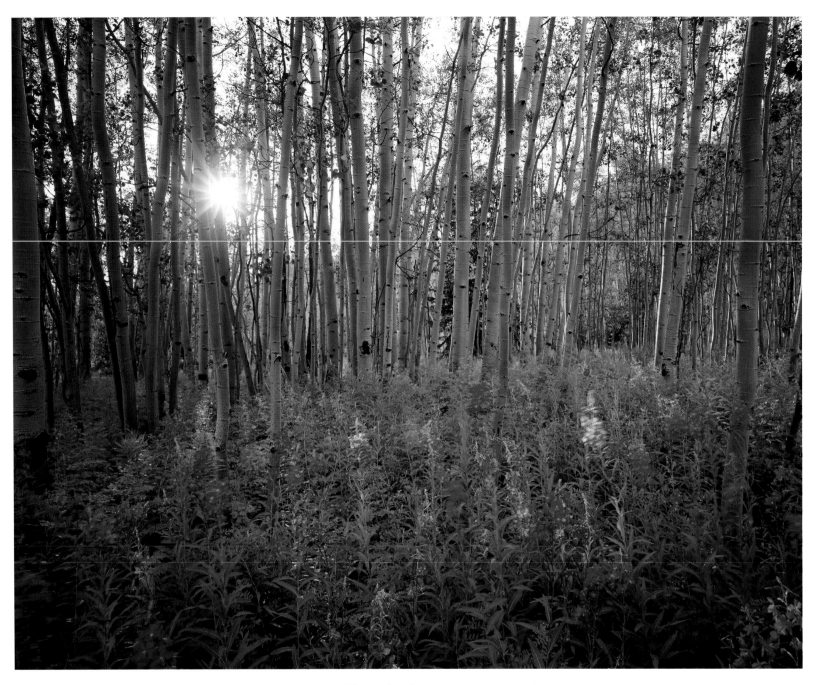

▲ Fireweed and aspen carpet
the ground in the Sawatch Range.
▶ Cumberland Peak rises 12,388 feet above sea level.

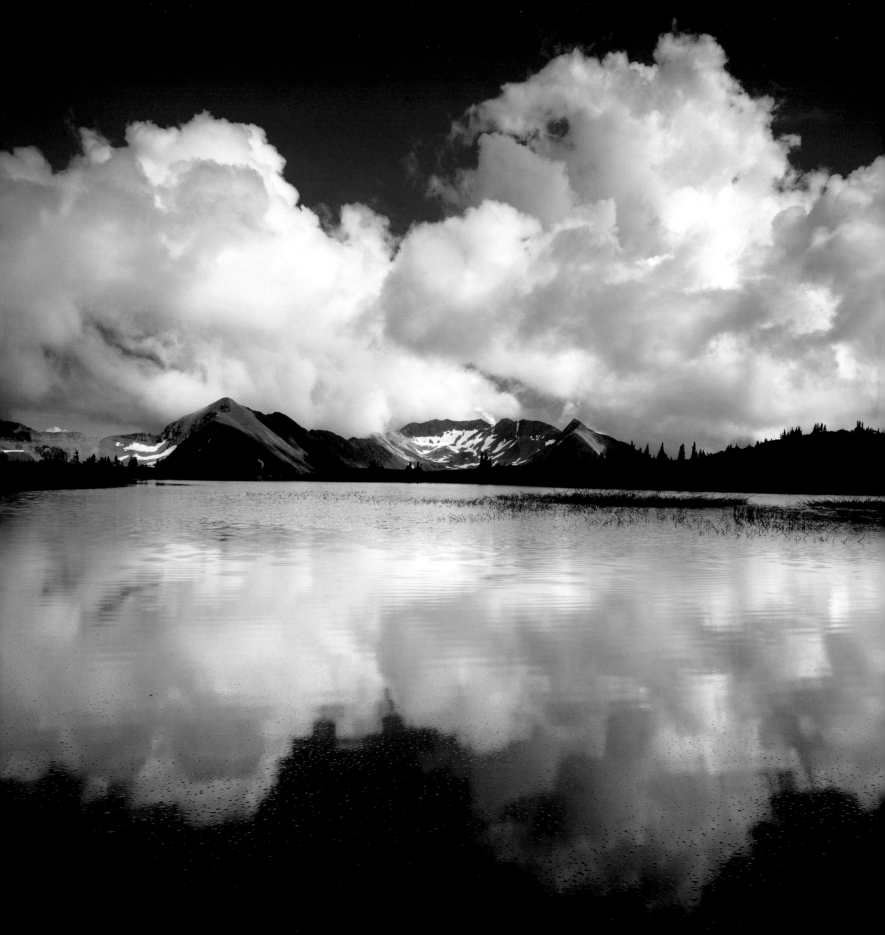

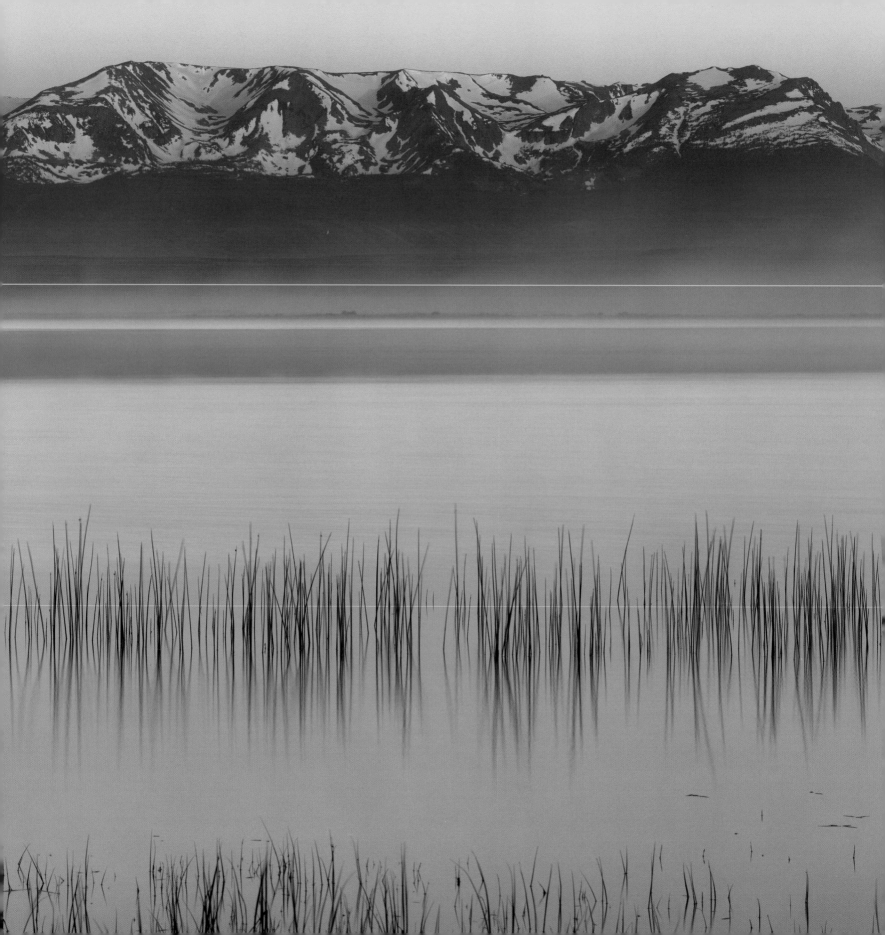

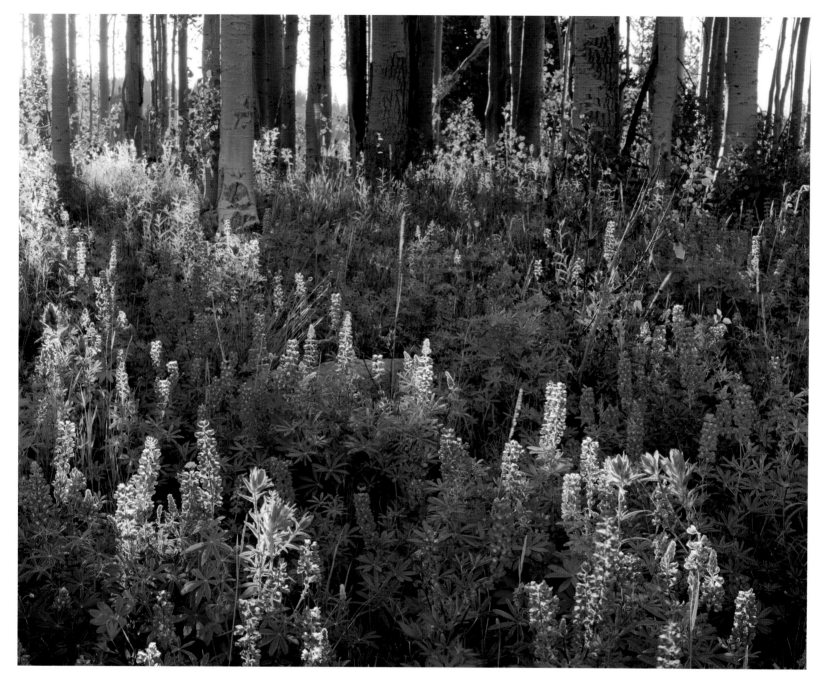

◄ Mount Zirkel, elevation 12,180 feet, rises above dawn reflections of reeds and
fog along the North Platte River in the Park Range's Zirkel Wilderness.
▲ Lupine and paintbrush cover the floor of an aspen grove
at Rabbit Ears Pass in Routt National Forest.

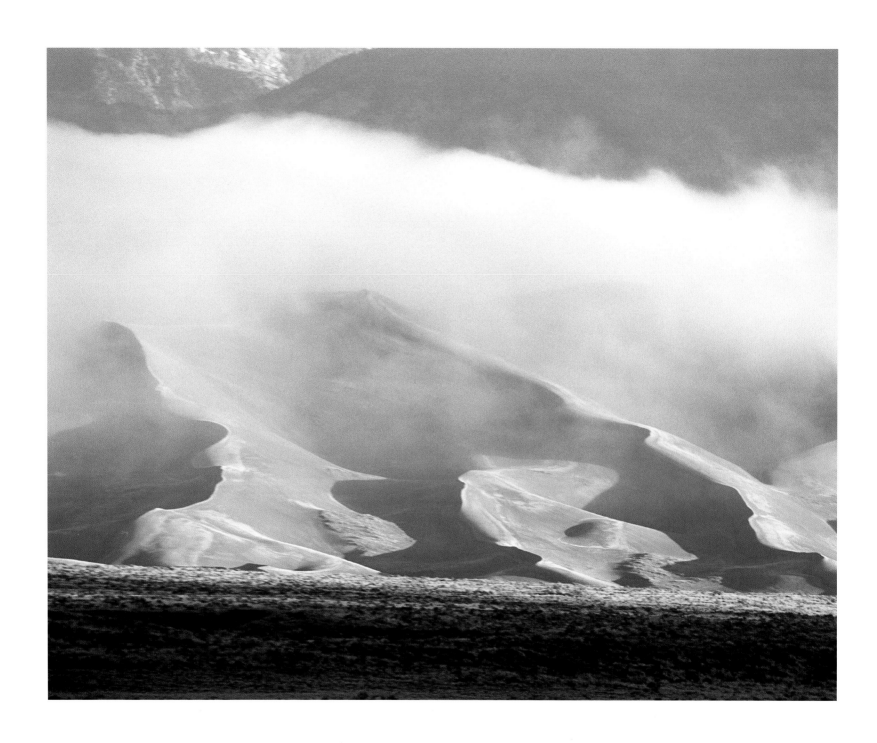

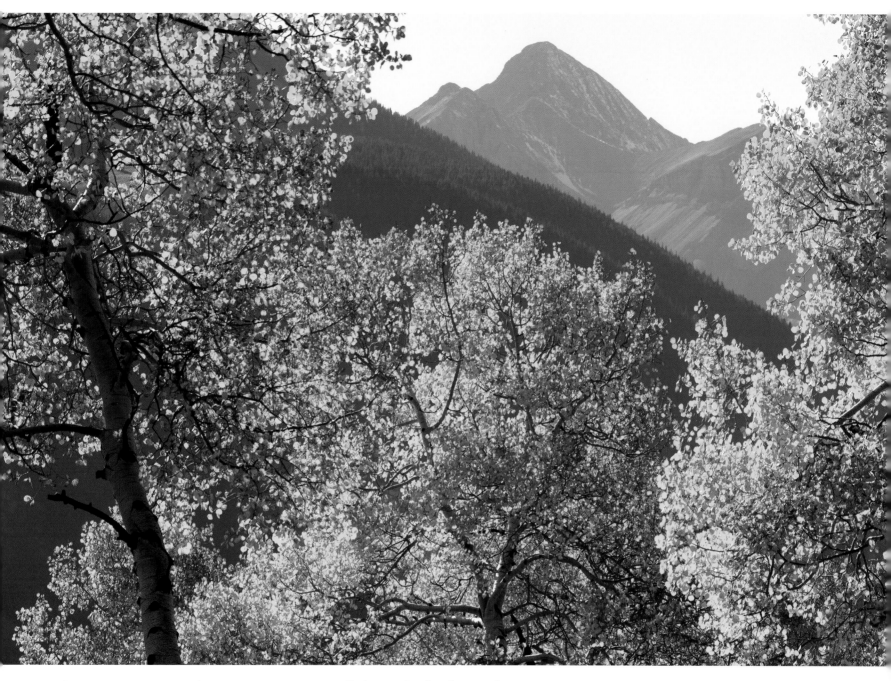

◄ Early morning fog obscures the tops
of the Sangre de Cristo Mountains, while a light
frost coats the Great Sand Dunes after a June storm.
▲ Aspens brighten the landscape in the San Miguel Mountains.
► ► Backcountry skiing, whitewater rafting, and technical
rock climbing—what do they all have in common?
Colorado.

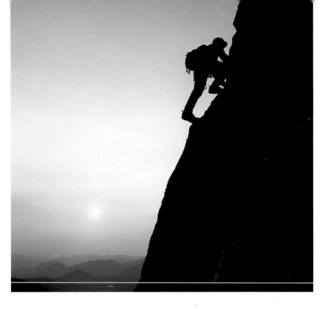

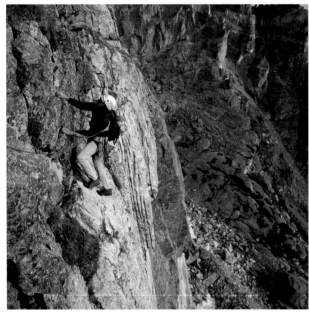

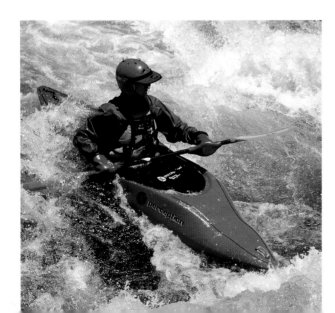

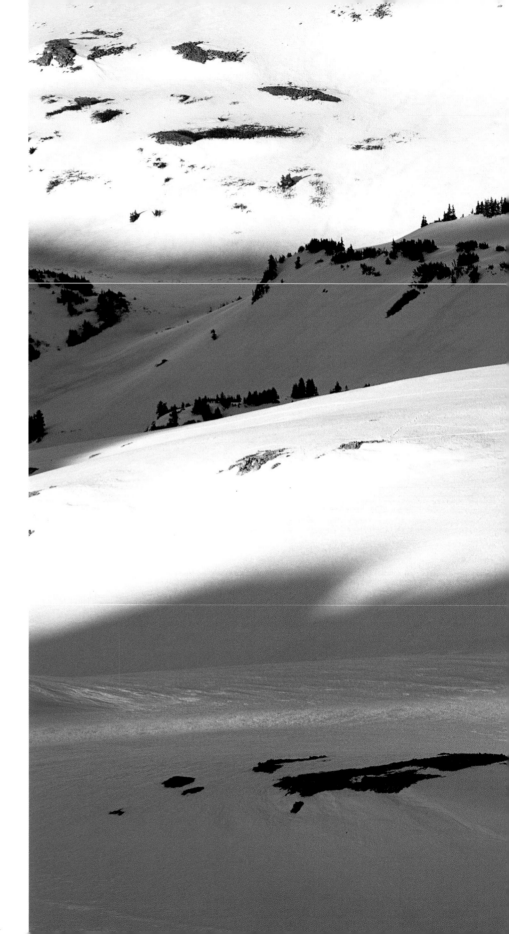

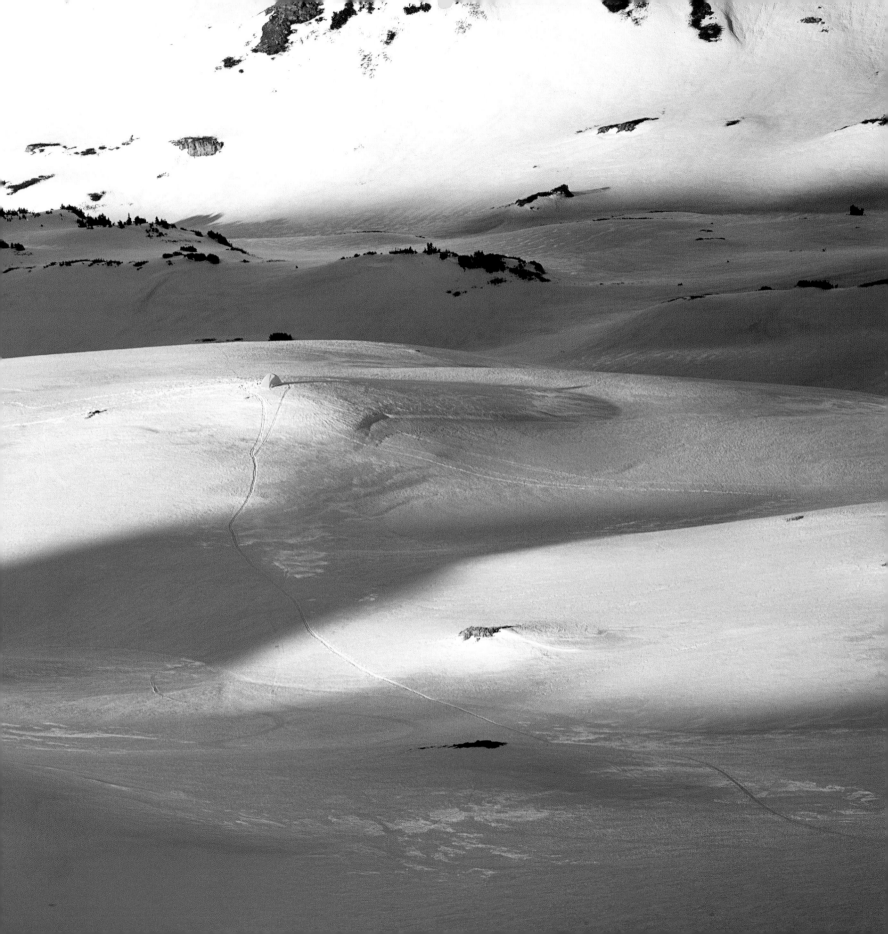

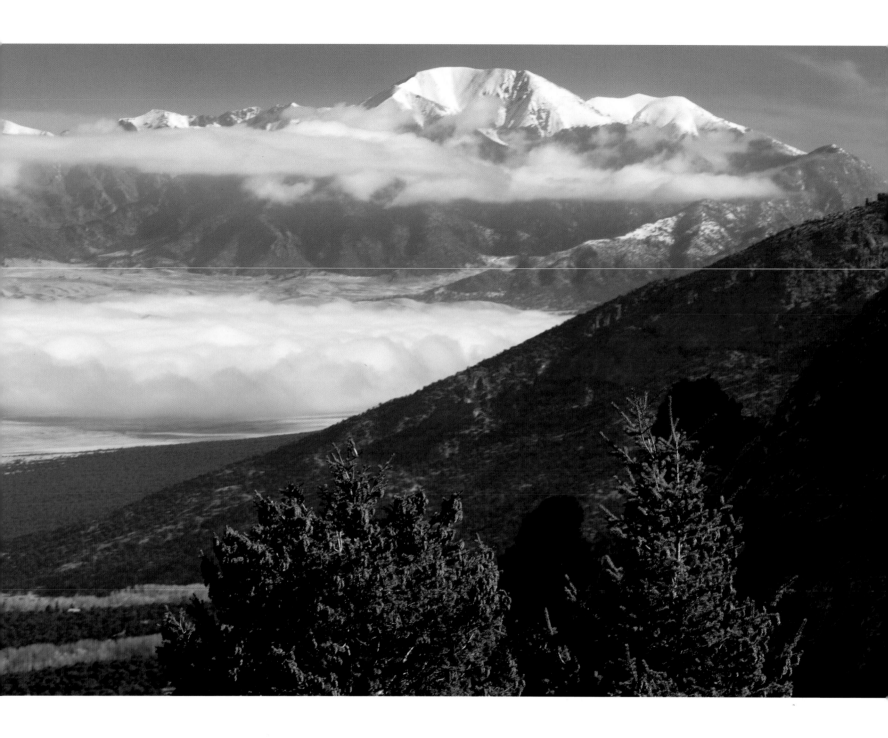

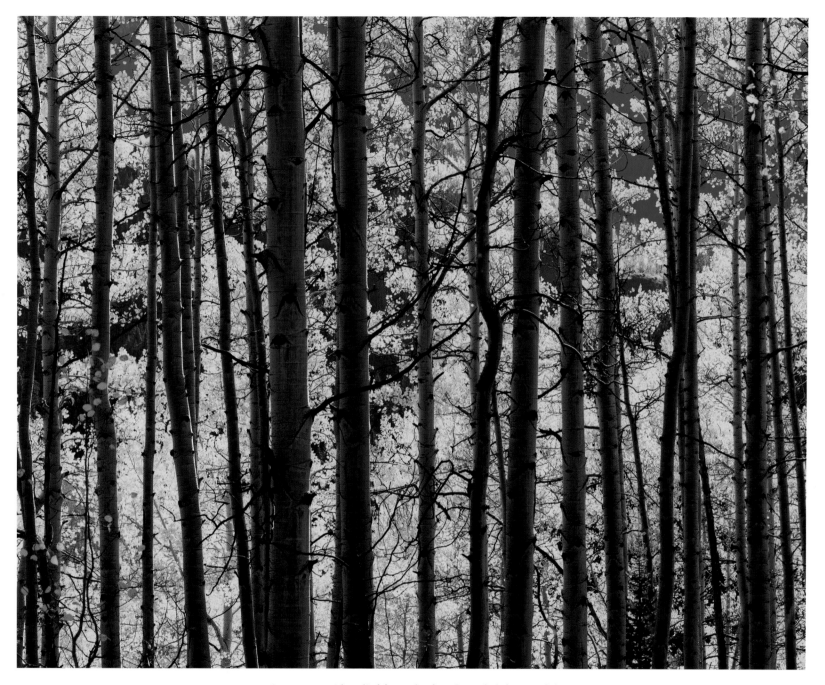

◄ Spruce provide relief from the fog-shrouded dunes of the
Zapata Falls area in Great Sand Dunes National Park.
▲ Aspen trees seem to take on a glow of their
own in the Rio Grande National Forest.

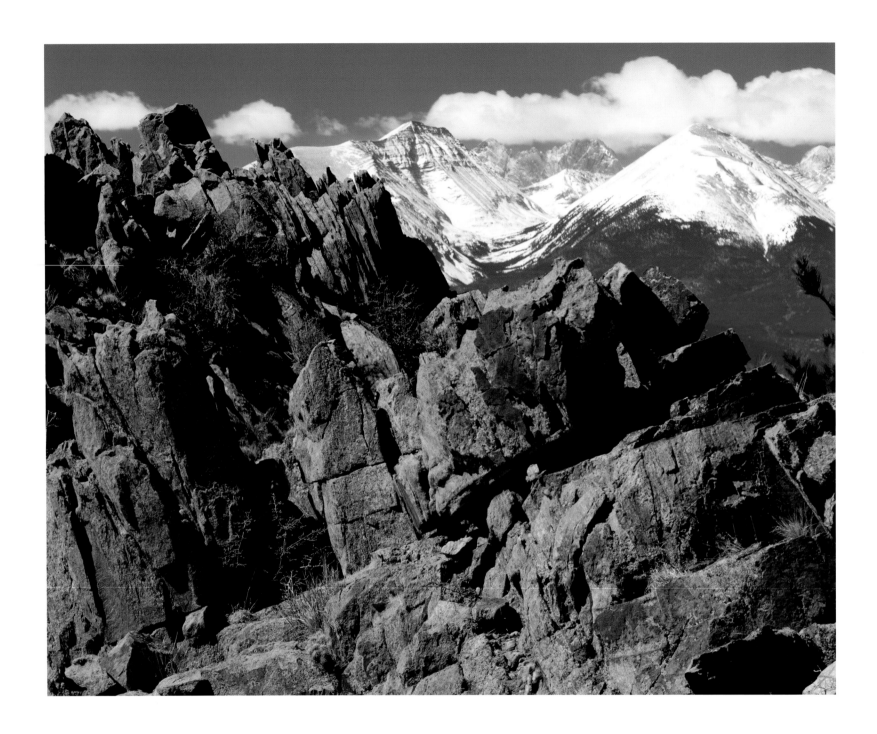

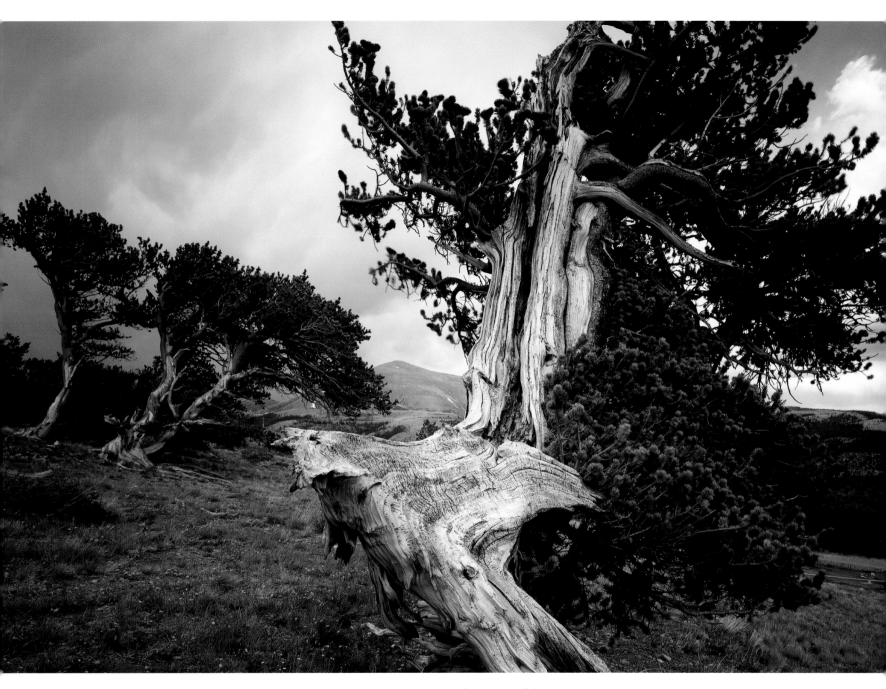

◄ A granite outcrop rises before peaks of the
Sangre de Cristo Range. Humbolt Peak (elevation 14,064
feet) and Crestone Peak (elevation 14,294 feet) are under cloud cover.
▲ Wildblown ice has sculpted these ancient bristlecone pines
at Windy Ridge Natural Area, near Alma,
in Pike National Forest.

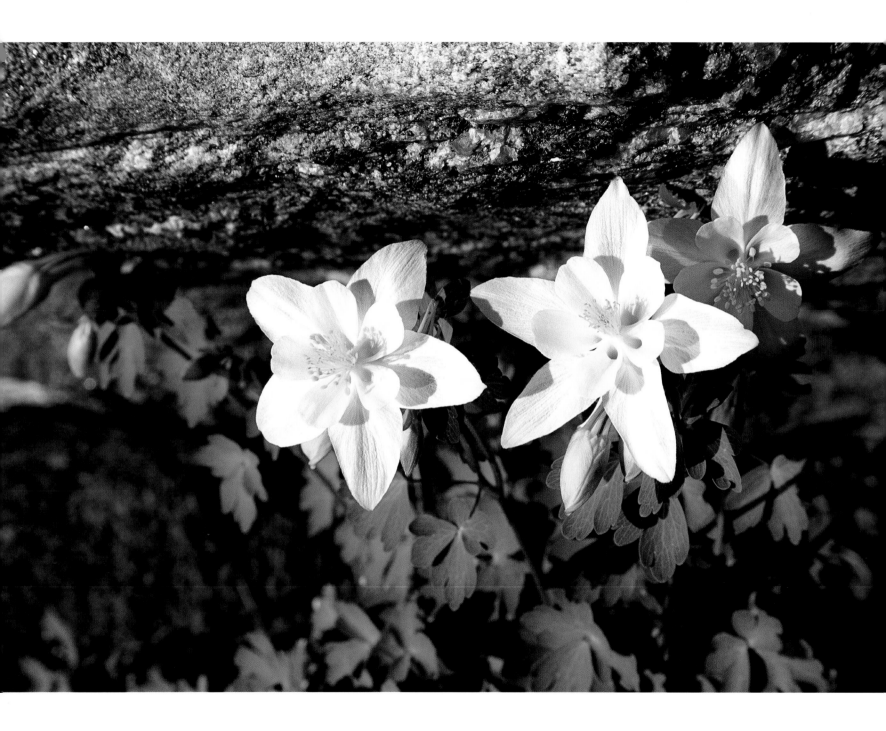

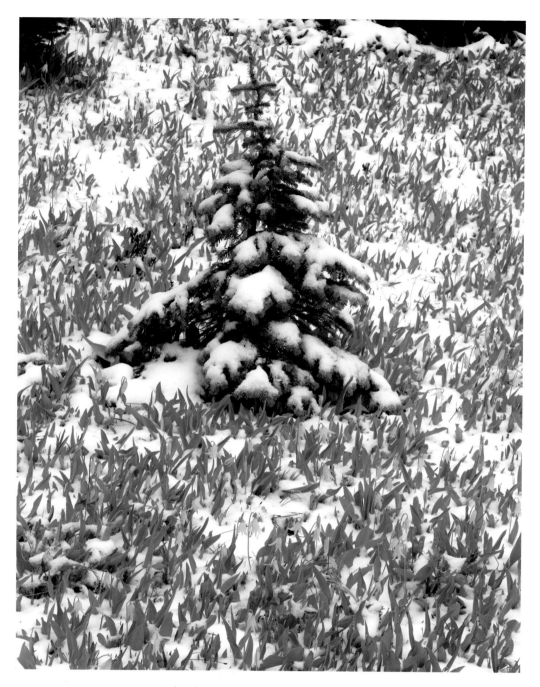

◄ Columbine blossoms brighten the timberline
zone below Mount Zirkel in Routt National Forest.
▲ An alpine fir is surrounded by glacier lilies, which seem
out of place in an early June snowstorm on Missouri Gulch.

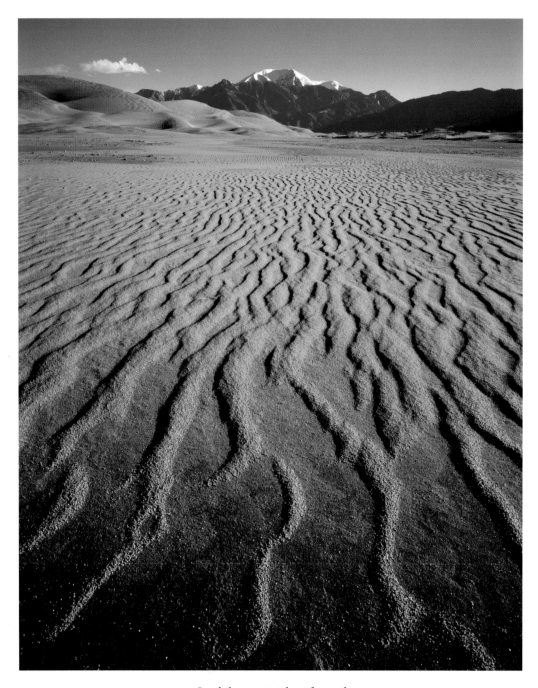

▲ Sand dunes stretch as far as the
eye can see, Great Sand Dunes National Park.
► Intriguing shapes give evidence that Roaring Fork, now
a hundred yards away, once flowed here and sculpted these rocks.

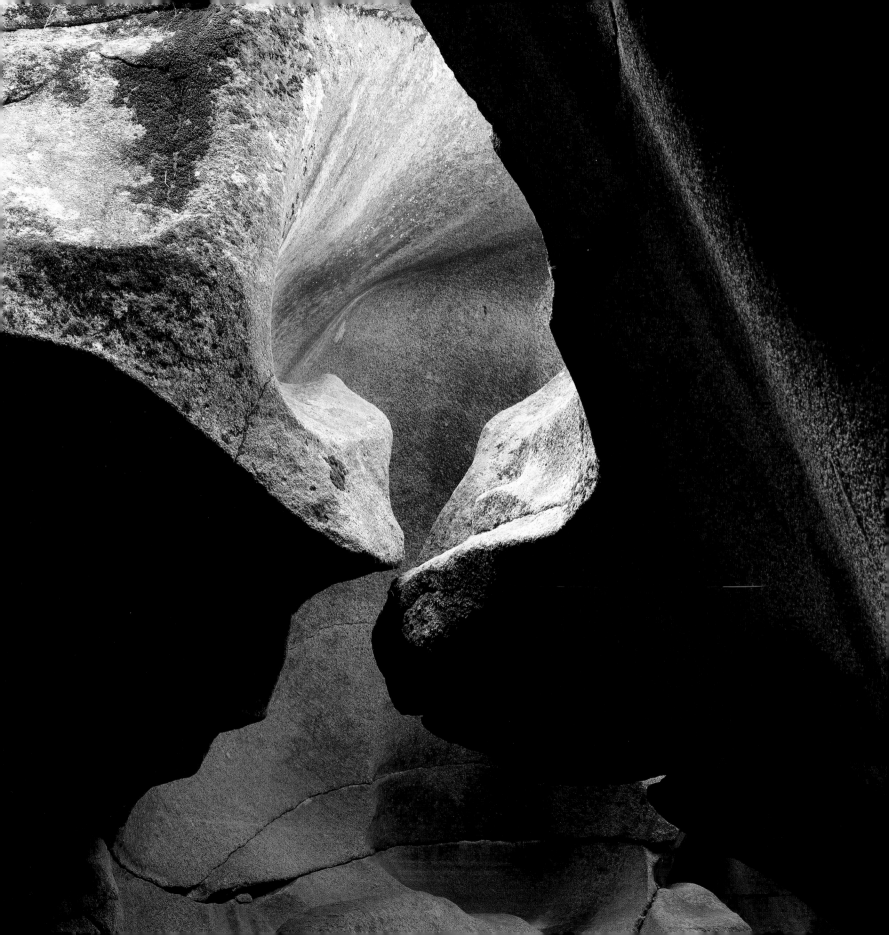

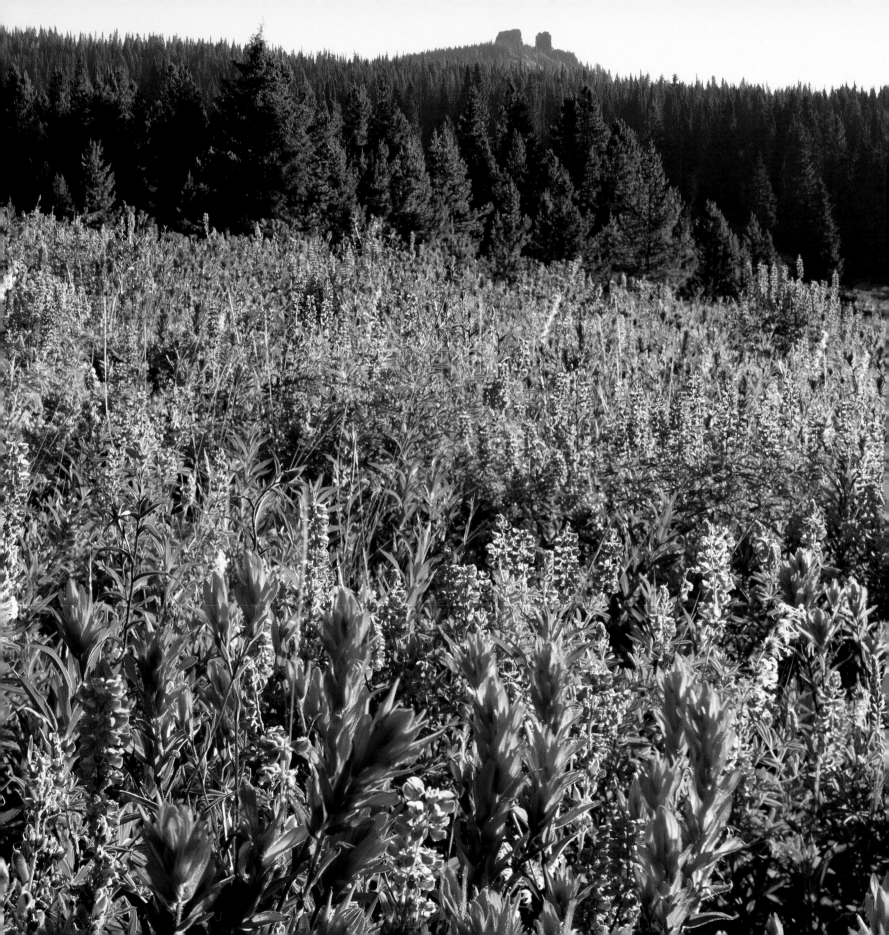

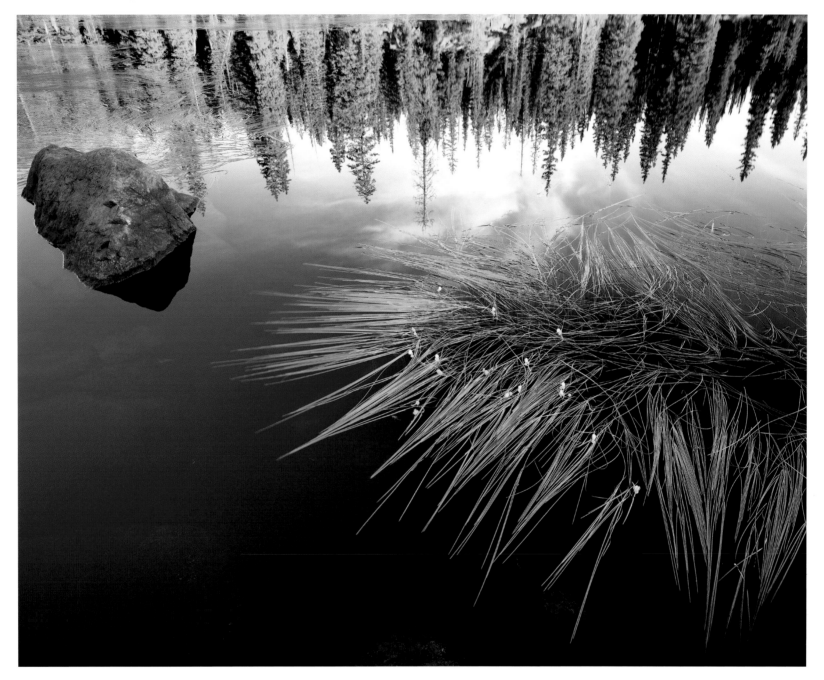

◄ Lupine and paintbrush carpet an open meadow of Rabbit Ears
Pass. The volcanic notches on the horizon are the Rabbit Ears Park Range.
▲ Pines add their reflection to the still waters of Eaglesmere Lake along
the eastern slope of the Eagles Nest Wilderness in the Gore Range.
► ► Fields of goldeneye and yampah bloom in mid-July
on the slopes of Washington Gulch.

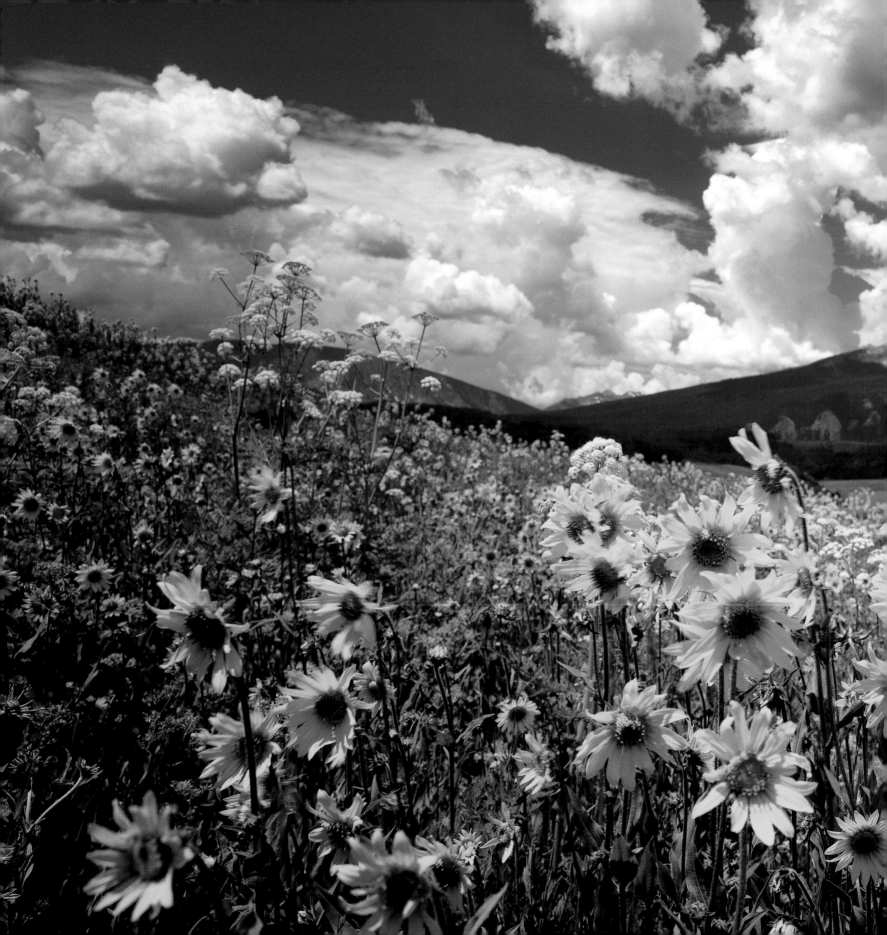

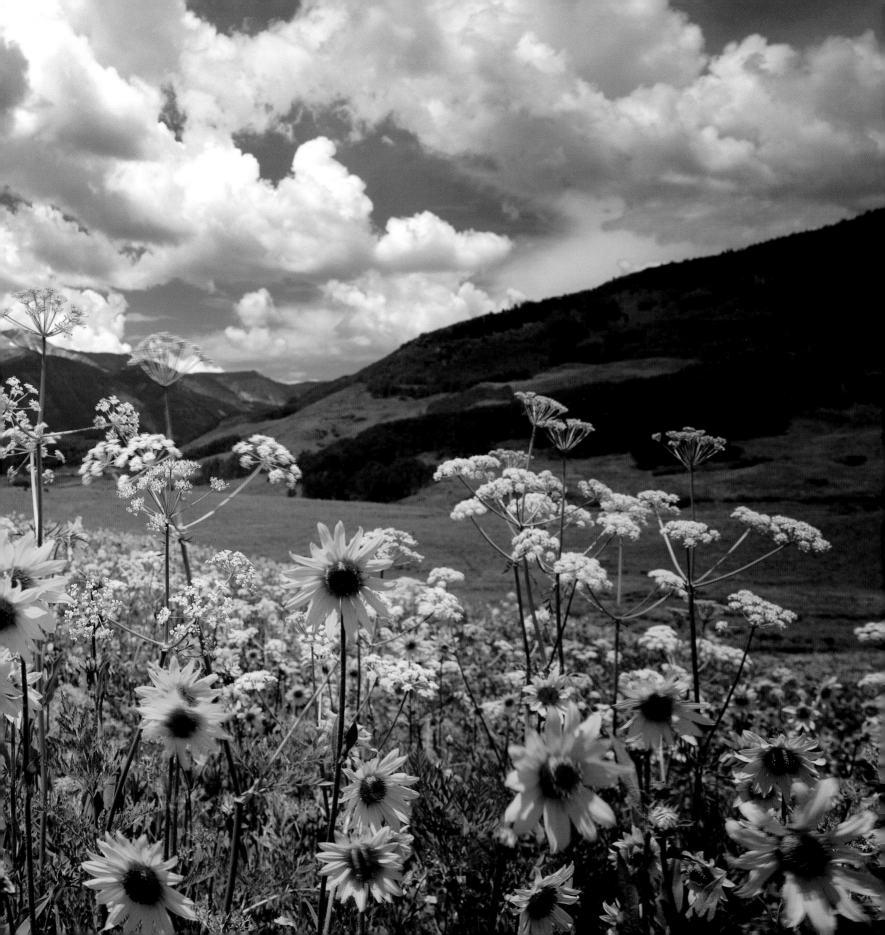

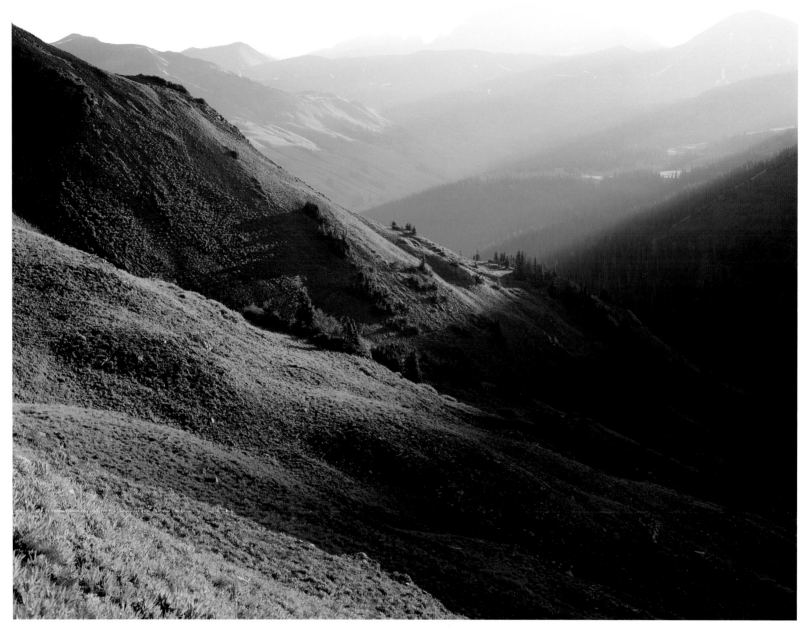

▲ Summer sun strikes the high
country of Maroon Bells–Snowmass Wilderness.
▶ Wild daisies mark the shoreline of a reservoir at the
edge of Indian Peaks Wilderness in the Arapaho National Forest.

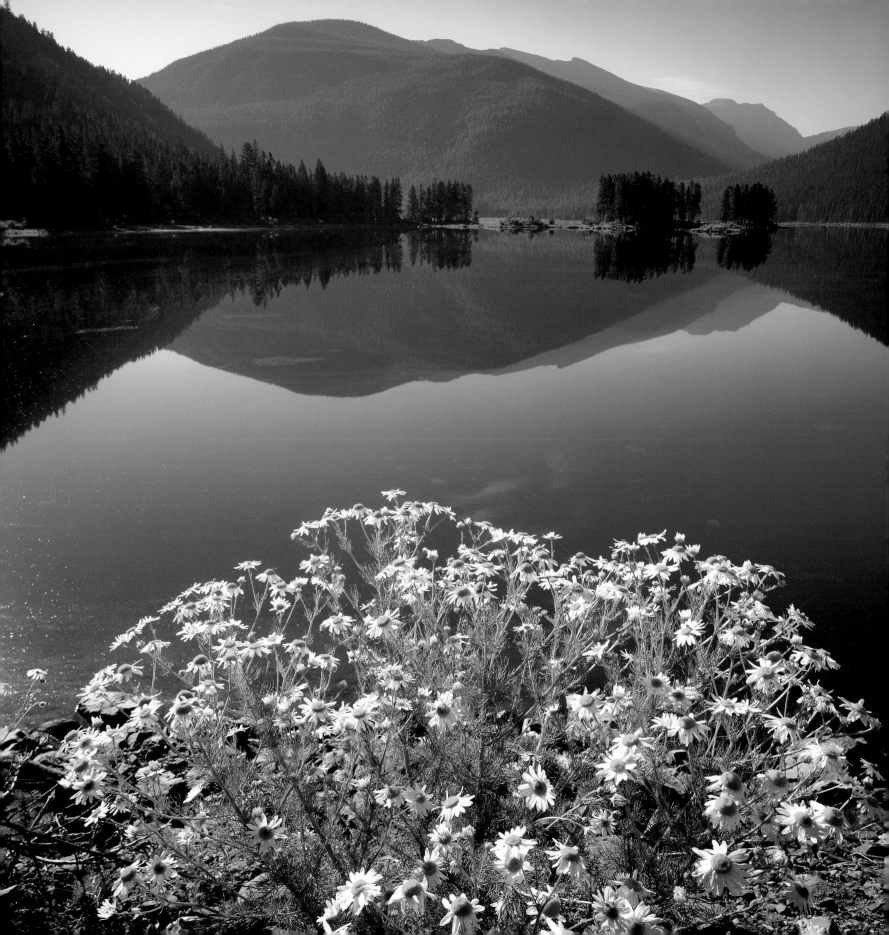

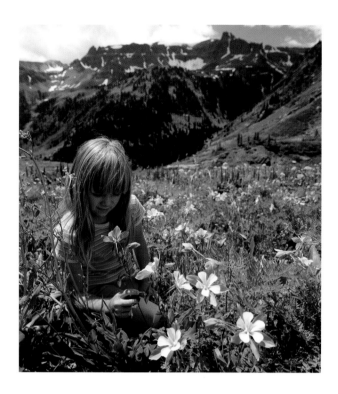

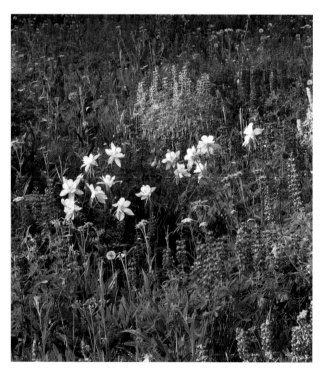

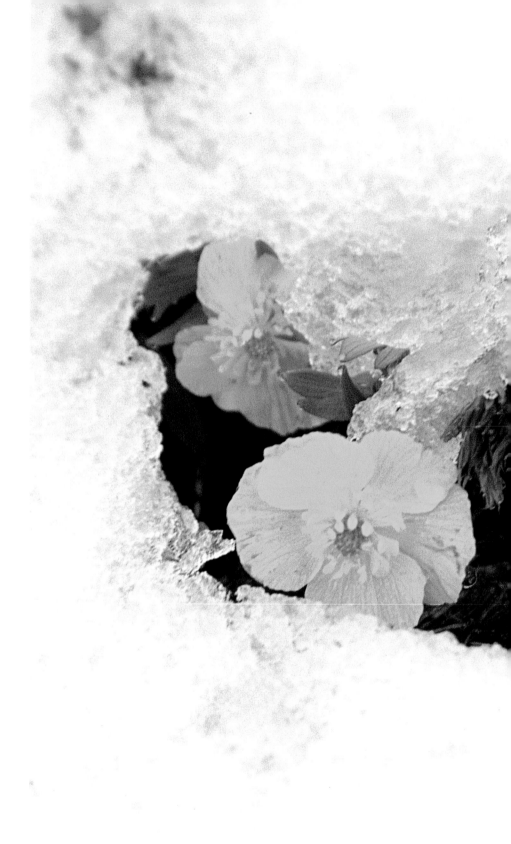

▲ lupine and columbine—the state flower—and
▶ Snow buttercup create a rich tapestry in the state's
high country from late June through September.

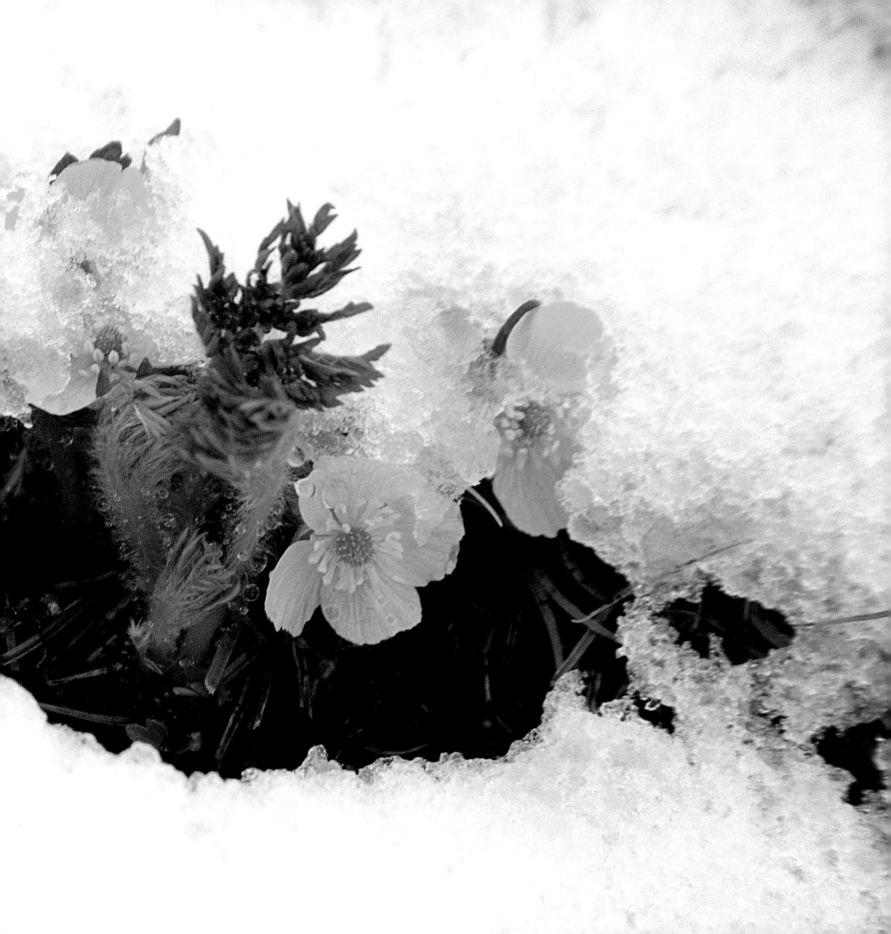

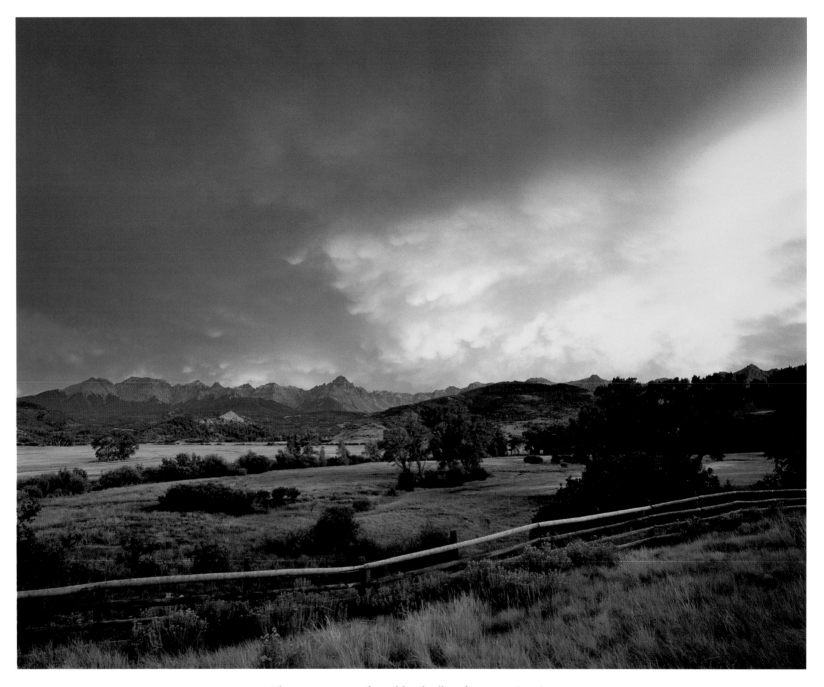

▲ The open spaces of ranchlands allow for expansive views
of spectacular 141,150-foot Mount Sneffels, north of Highway 62.
► Lined with cow parsnips, Maroon Creek, at the outlet of Maroon
Lake in the Elk Range, reflects the light of a summer dawn.
► ► A low August flow in Roaring Fork has created
an unusual opportunity to photograph
the stream's bedrock sculpture.

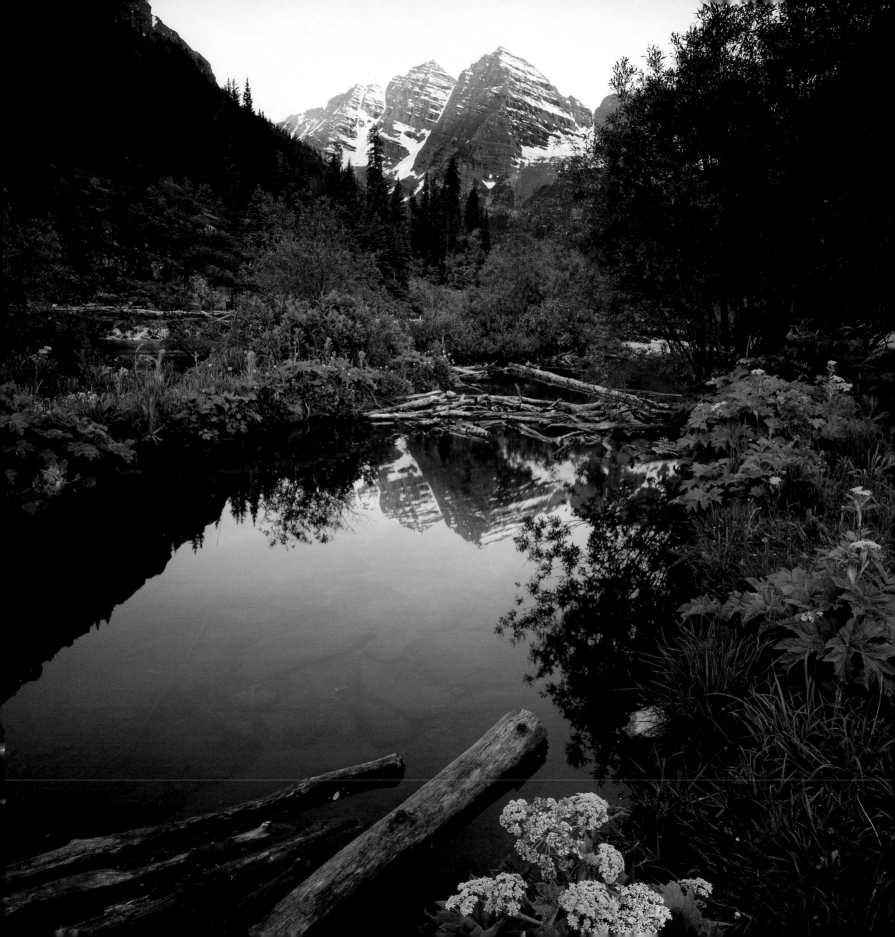

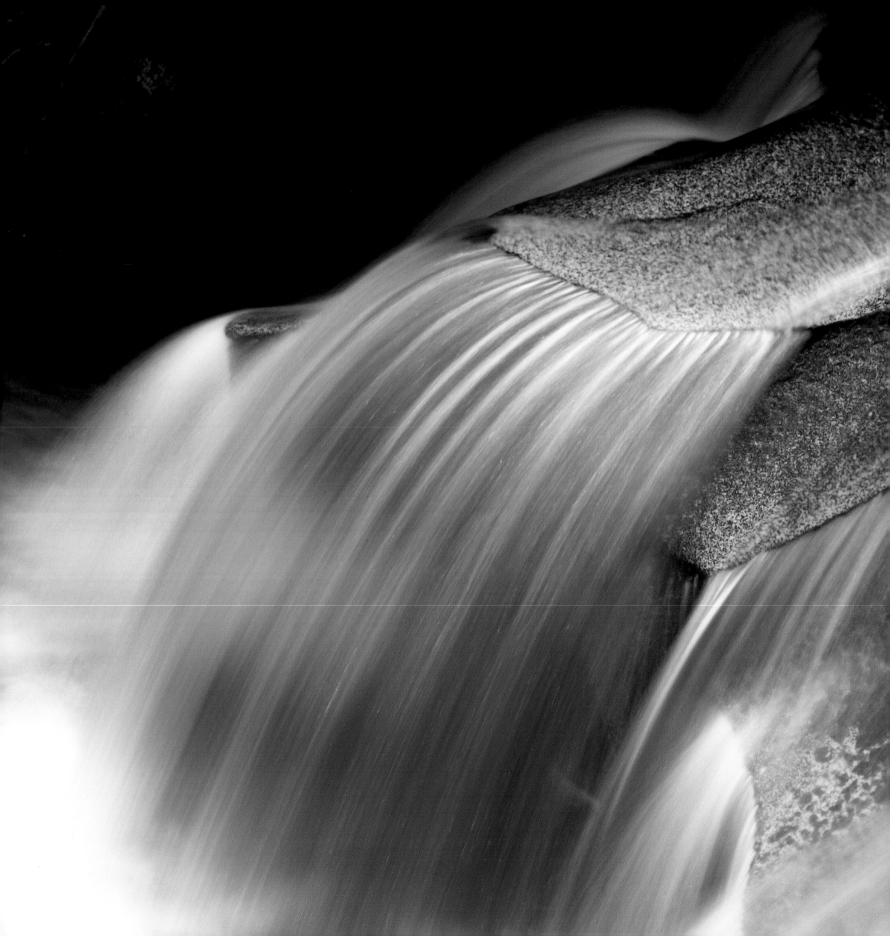

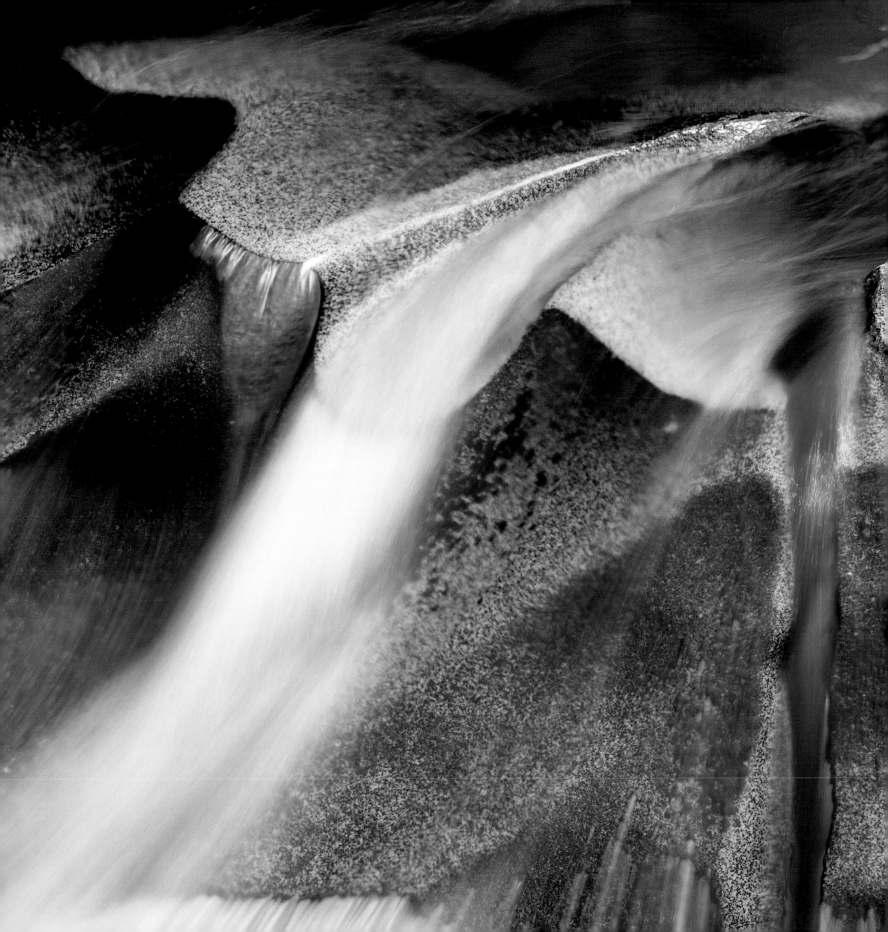

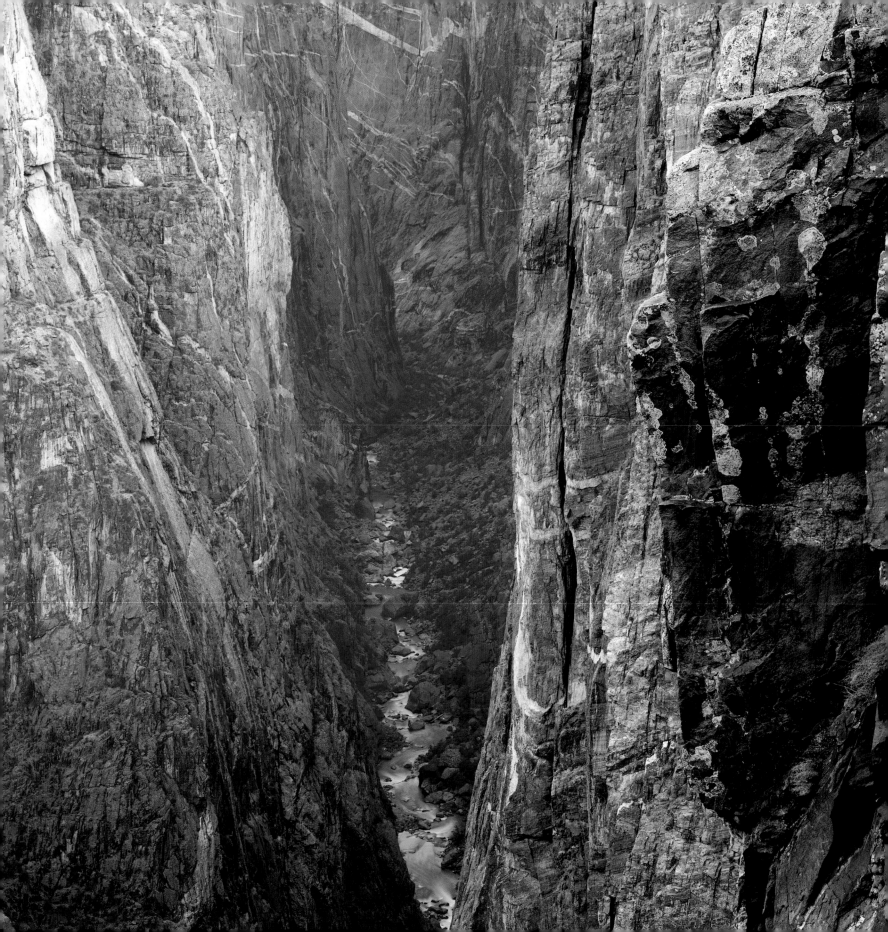

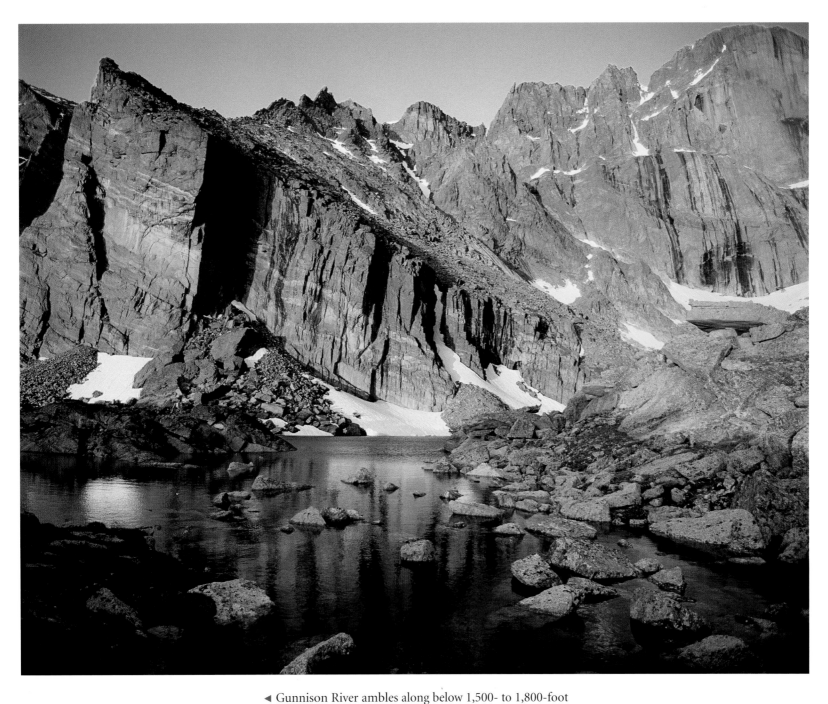

◄ Gunnison River ambles along below 1,500- to 1,800-foot
metamorphic walls in Black Canyon of the Gunnison National Park.
▲ Chasm Lake was created by the Mills Glacier, which tore away the eastern
section of 14,255-foot Longs Peak and created the immense
3,000-foot granite wall called "the Diamond."

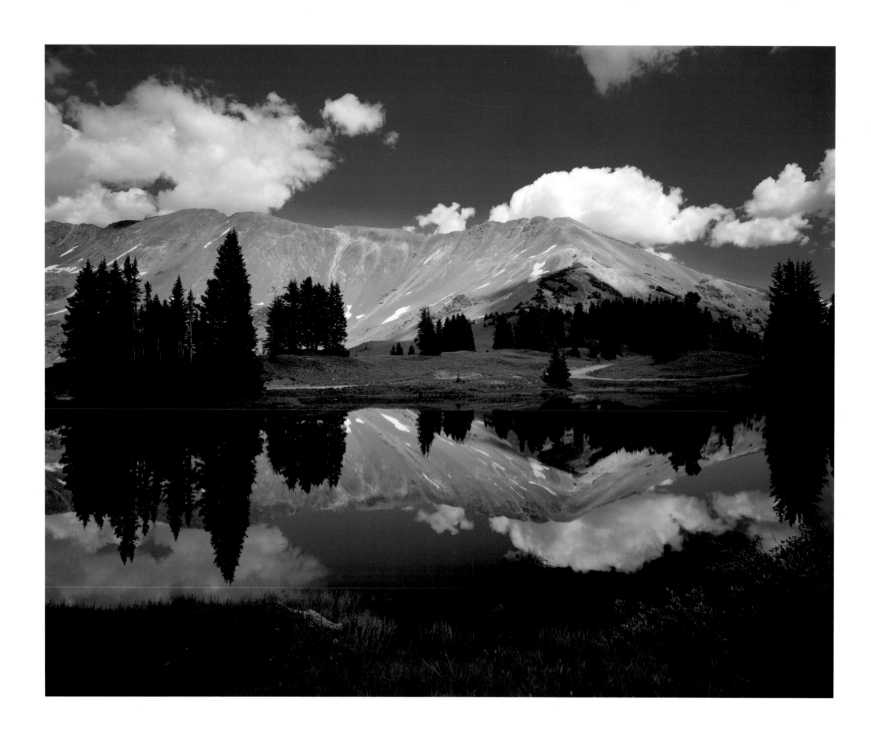

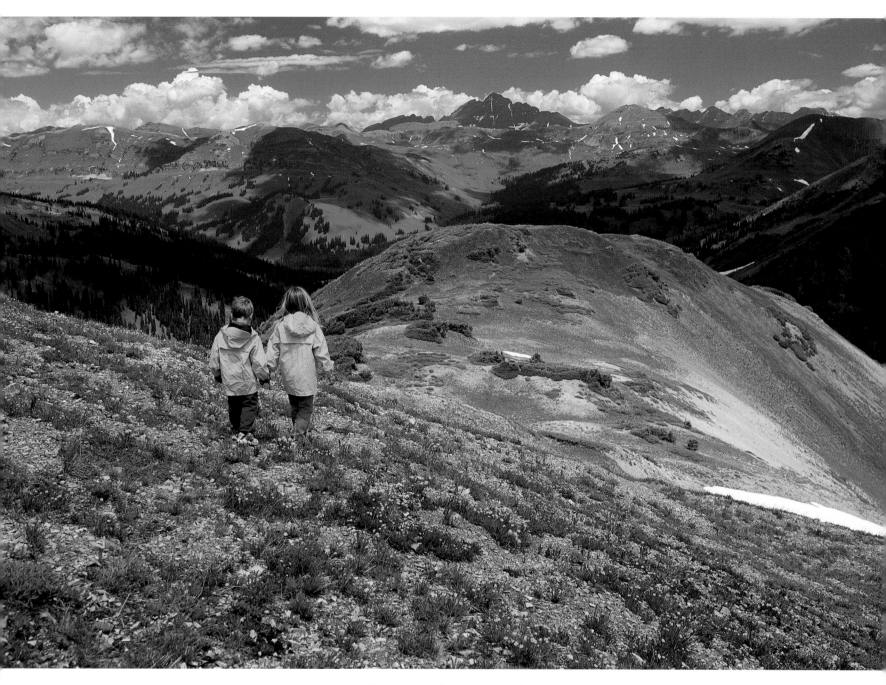

◄ Mount Baldy, stained with iron oxide, exhibits the
characteristic red brown color of the Rocky Mountains in Colorado.
▲ Children step through the wildflowers at 12,000 feet, with
the 14,000-foot-plus Maroon Bells in the distance.

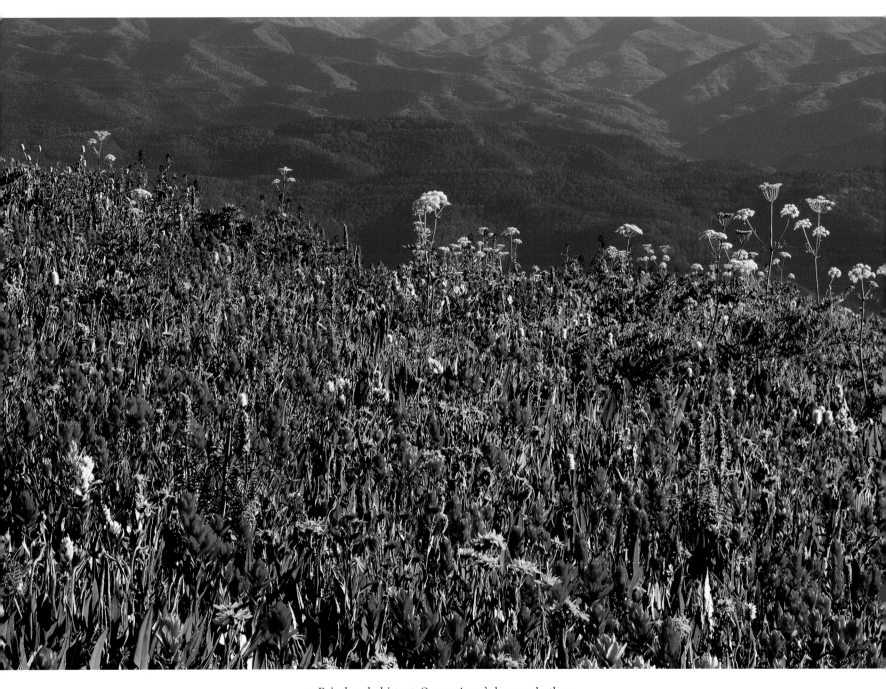

▲ Paintbrush, bistort, Queen Anne's lace, and other
blossoms brighten the Cumberland Basin in La Plata Mountains.
▶ White daisies of summer decorate a rustic fence along the Hermosa Cliffs above Durango.
▶ ▶ Fort Peabody was once manned with armed guards to keep miners
from escaping the harsh conditions of the Tomboy Mine. It now
makes a weathered frame for 14,150-foot Mount Sneffels

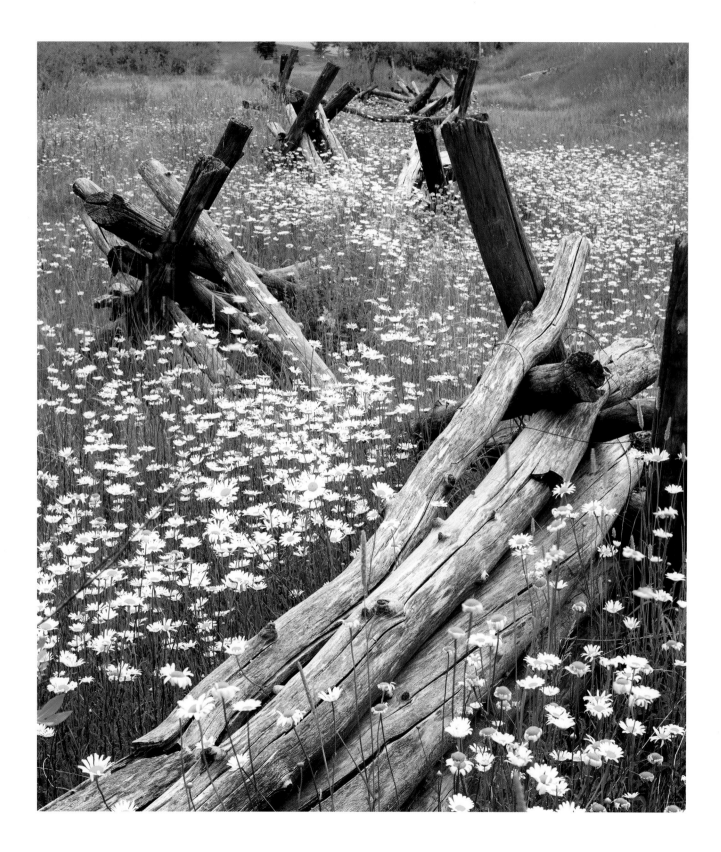

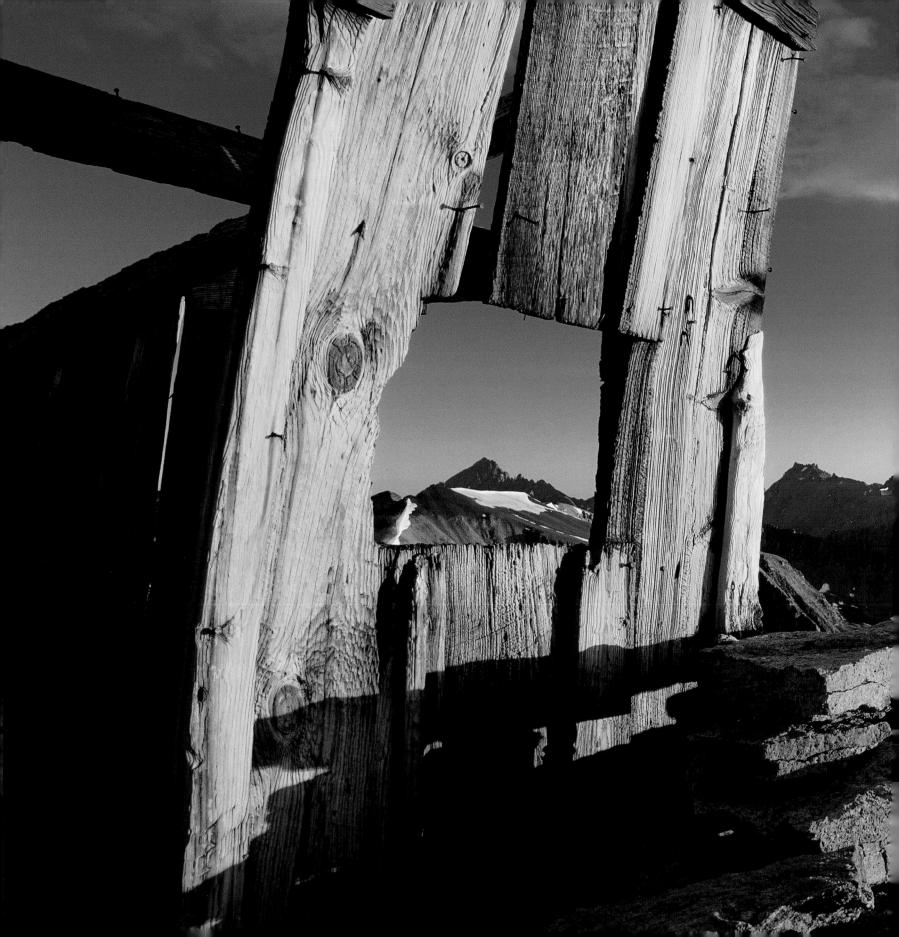

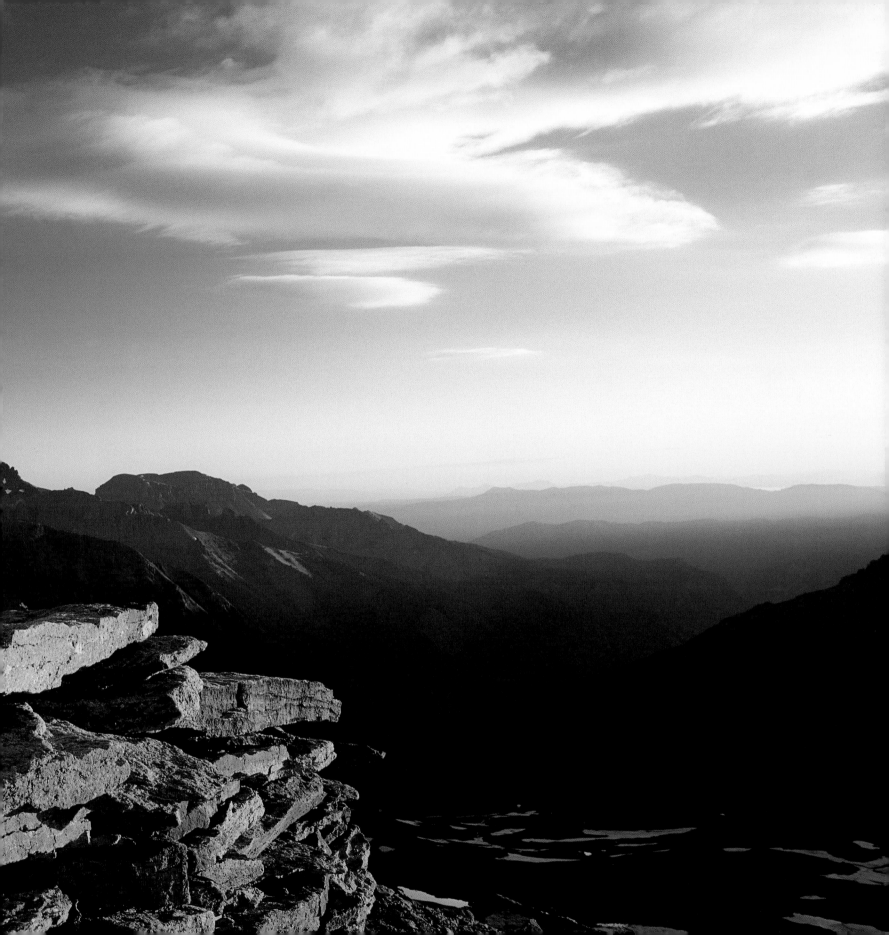

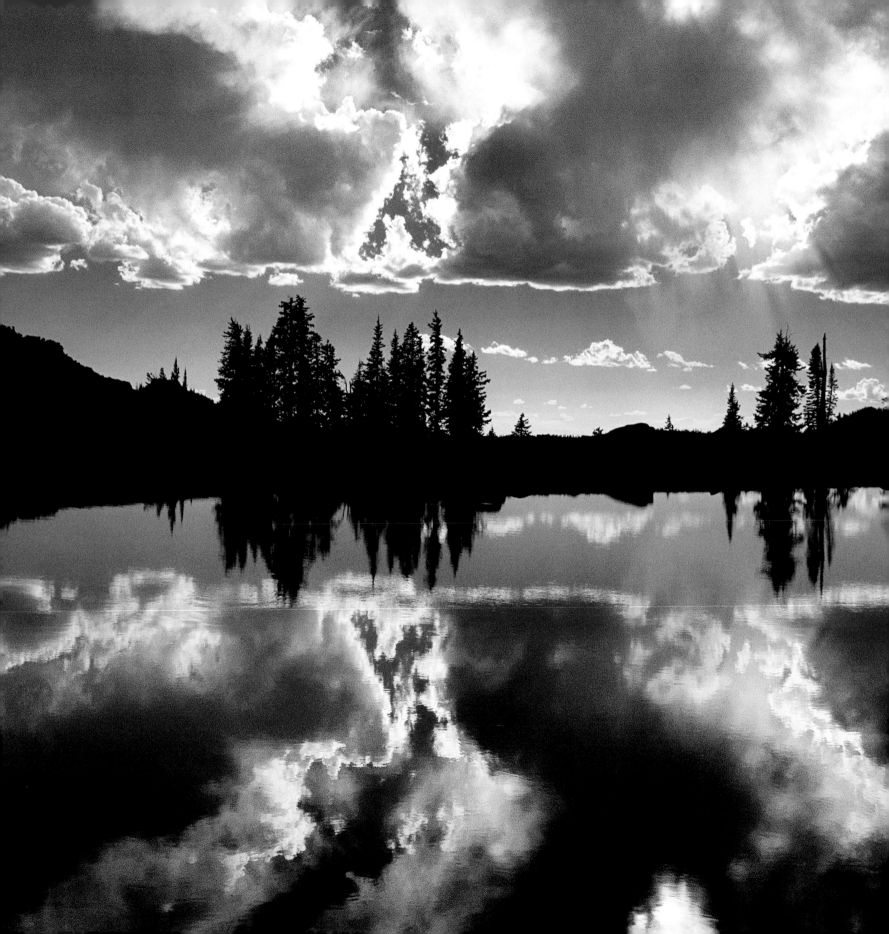

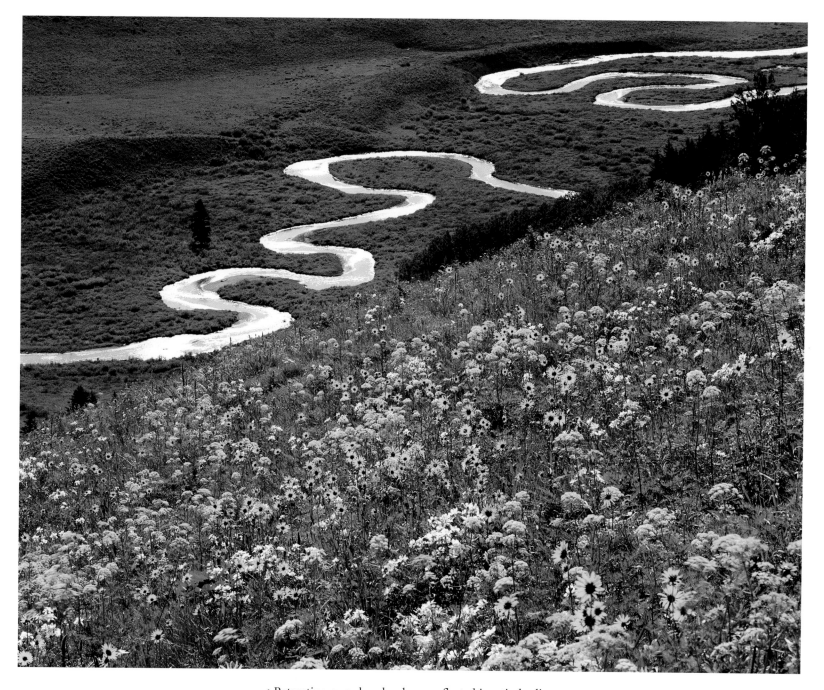

◀ Retreating cumulus clouds are reflected in a timberline
pond below 12,180-foot Mount Zirkel in Routt National Forest.
▲ Wildflowers bloom on the slopes of Mount Crested Butte above the East River.
▶ ▶ Case's fireweed, *Corydalis caseana brandegei*, brightens a hillside at Washington Gulch.

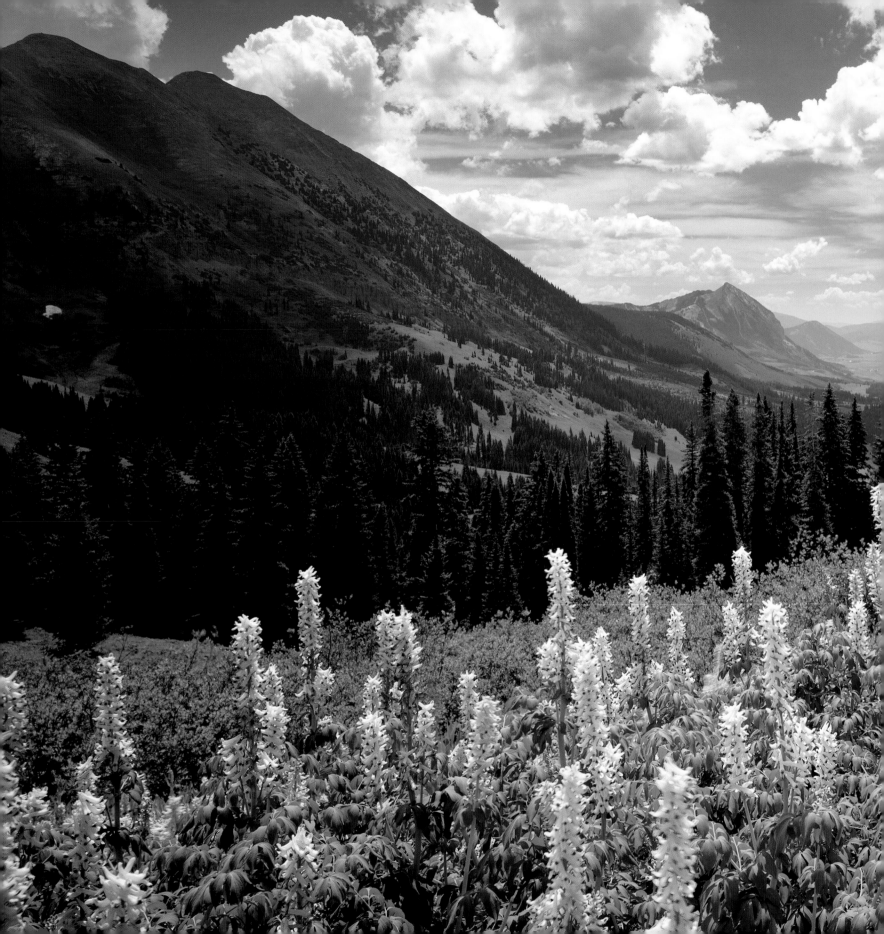

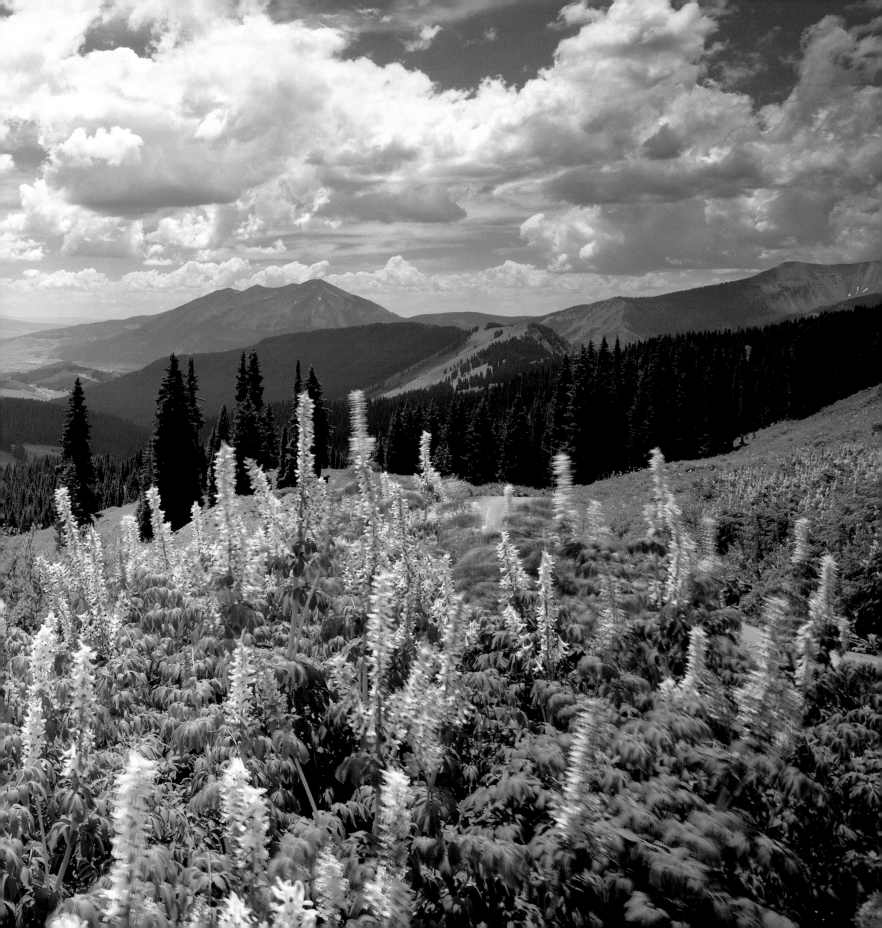

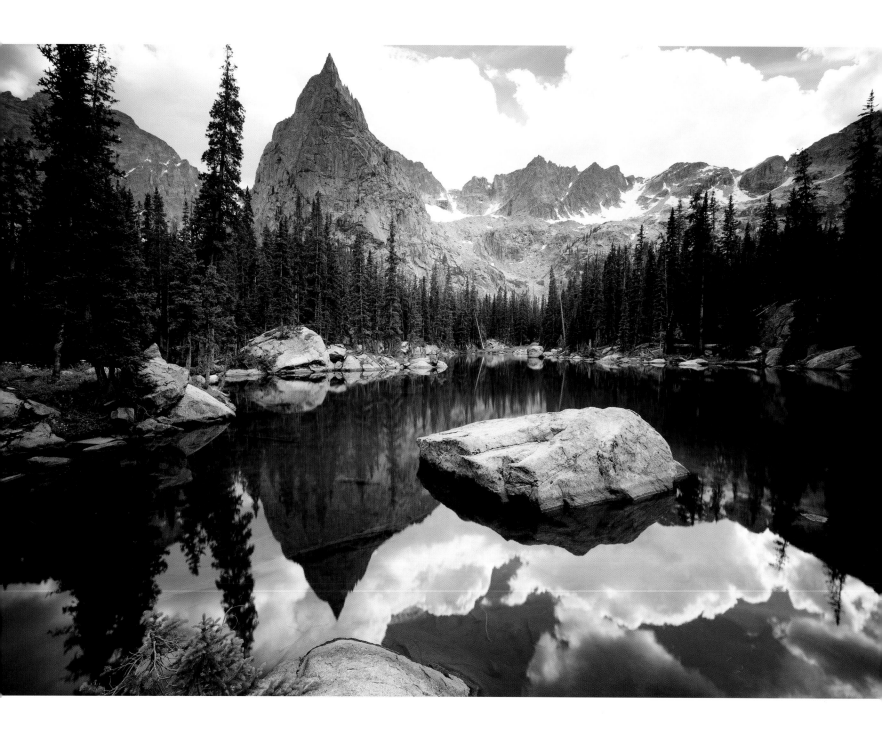

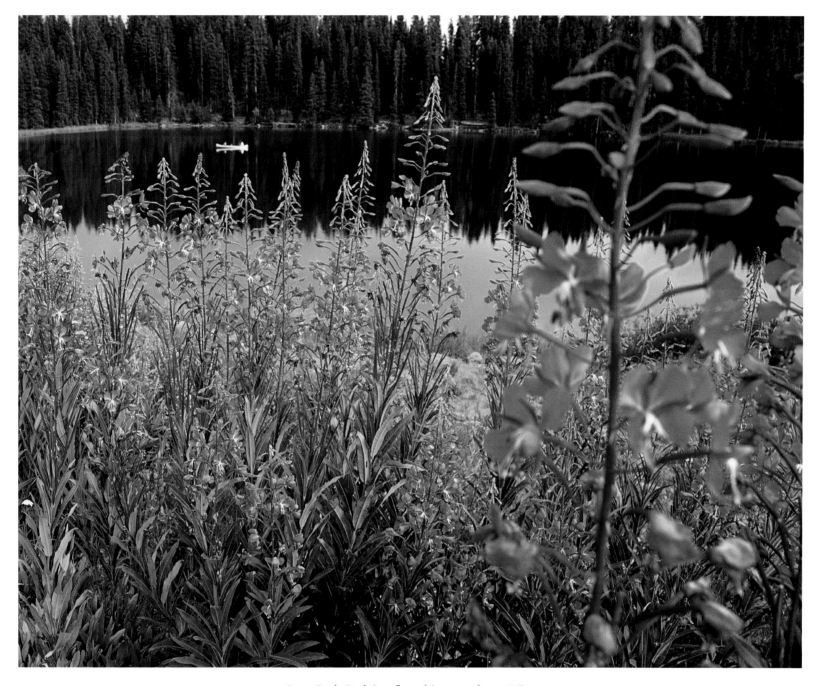

◄ Lone Eagle Peak is reflected in a pond near Mirror
Lake in the Indian Peaks Wilderness, Arapaho National Forest.
▲ Fireweed lines Patterson Reservoir along the southwest
side of Grand Mesa, in Grand Mesa National Forest.

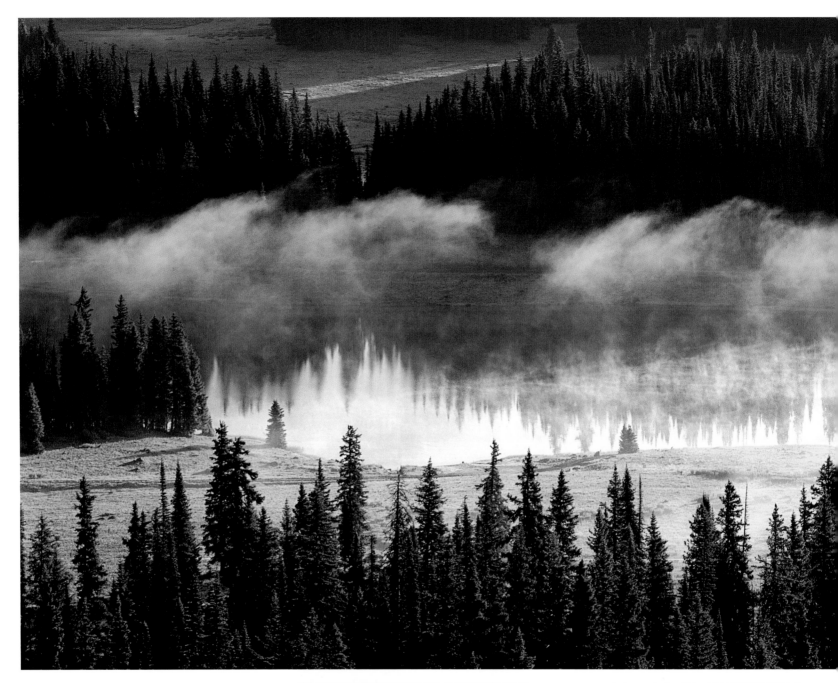

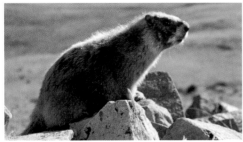
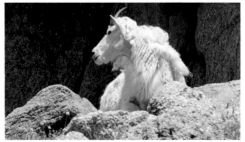
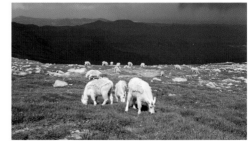

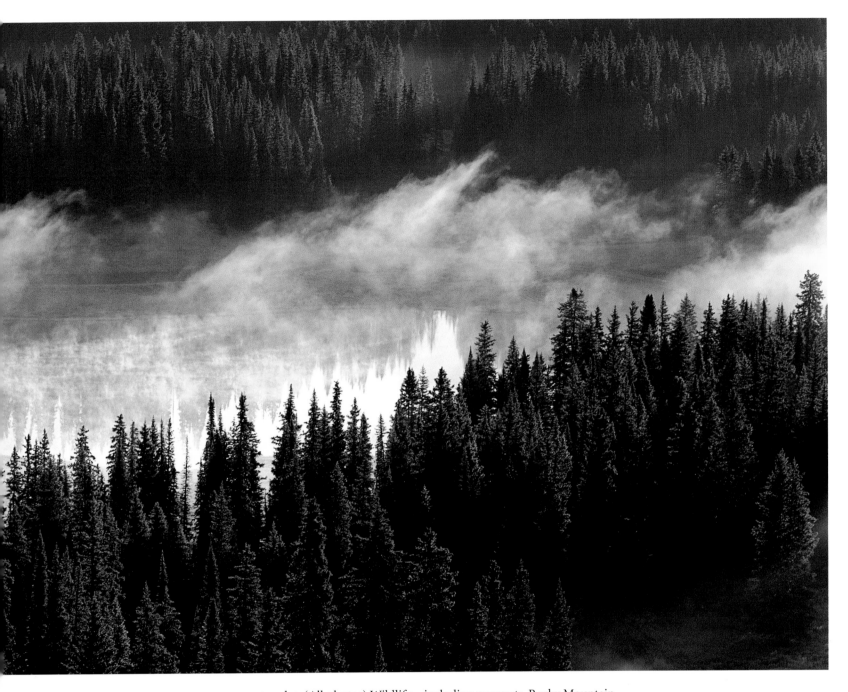

◄ and ▲ (All photos) Wildlife—including marmots, Rocky Mountain
big horn sheep, and mountain goats—now flourishes as a result
of careful preservation of large sections of land in the state.

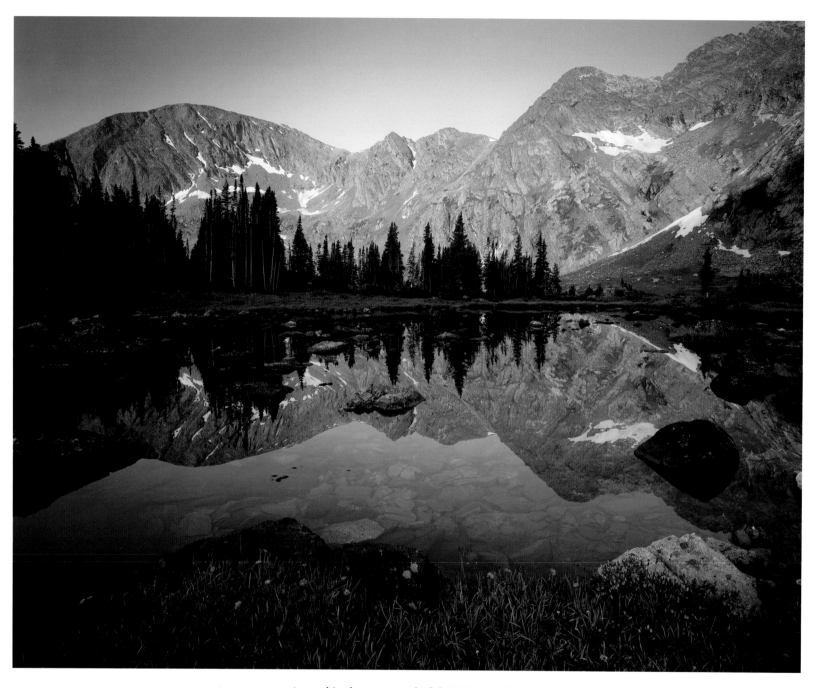

▲ A pond in the upper end of the Missouri Gulch
reflects mountains at the north end of the Sawatch Range.
► The granite walls of Black Canyon of the Gunnison National Park shelter
the waters that flow at the bottom of the deep canyon.

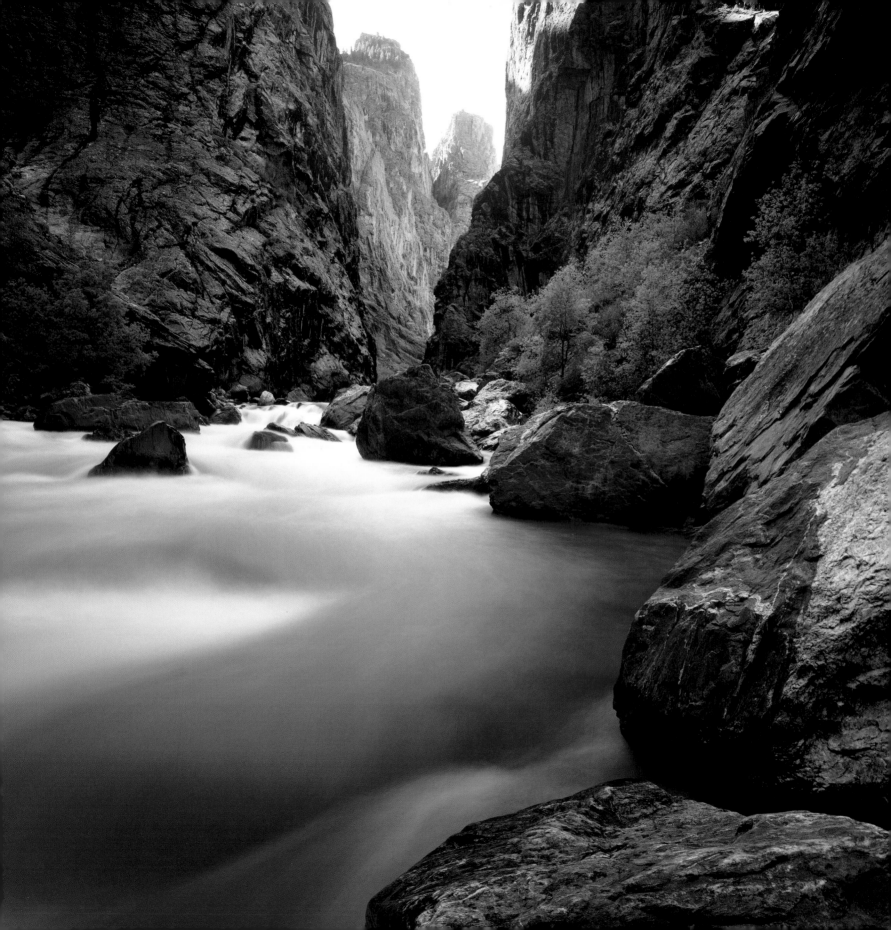

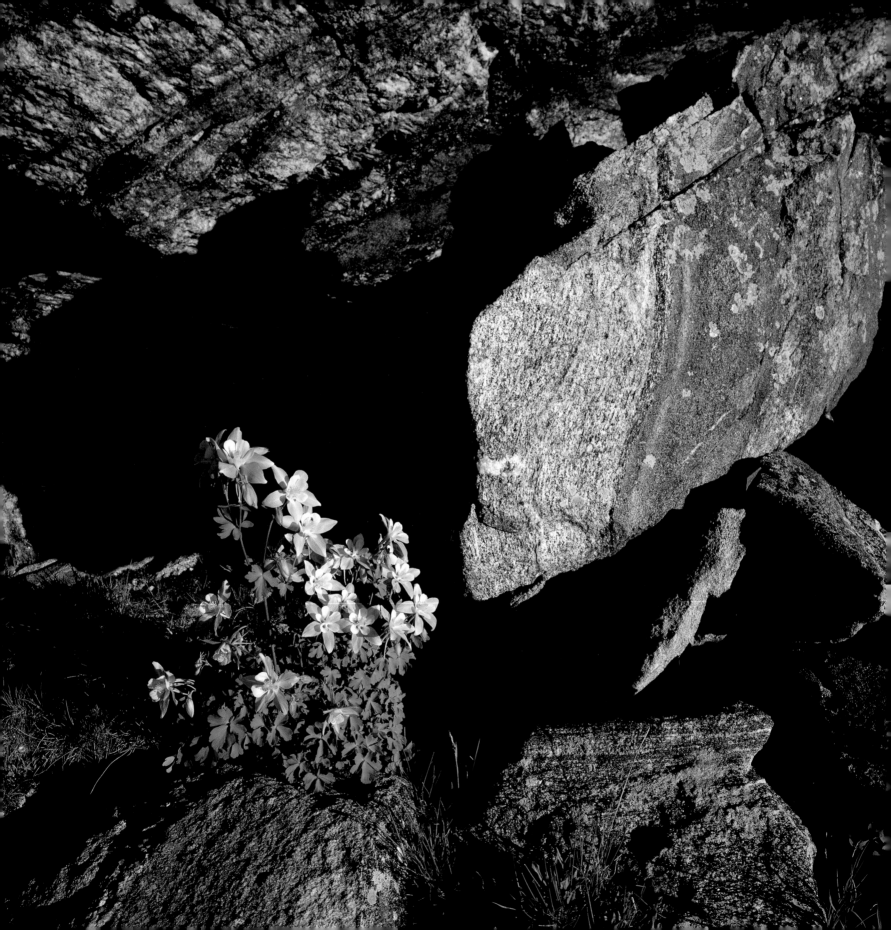

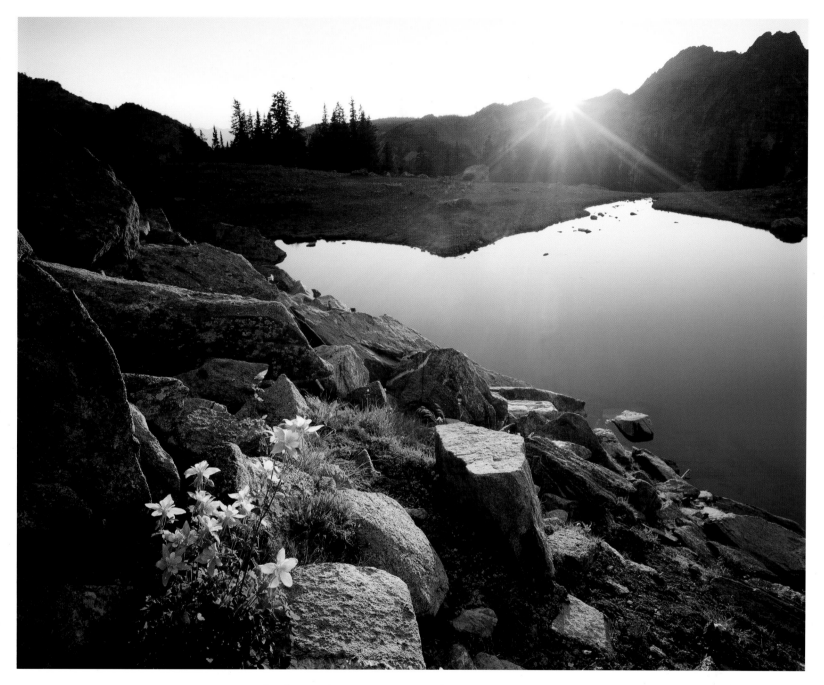

◄ Columbine and granite alluvial boulders form a collage along the
west side of the Park Range below Mount Zirkel in Routt National Forest.
▲ Columbine brightens an alpine pond in Mount Zirkel Wilderness.

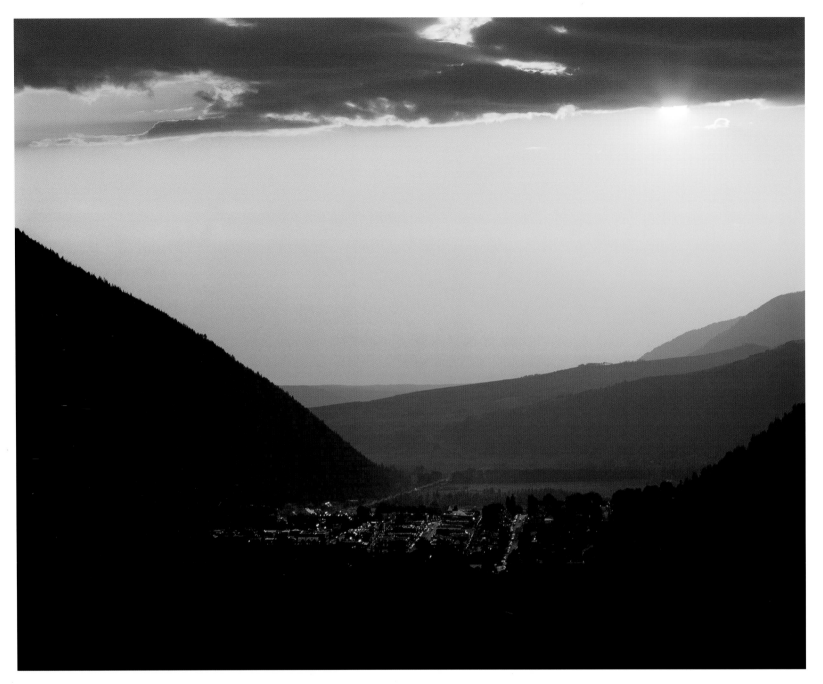

▲ The mountains west of Telluride are scattered, allowing enough
open space for one to watch the sun set into the sandstone canyons of Utah.
▶ Independence Rock rises against Monument Canyon in this view
east to Grand Mesa in Colorado National Monument.

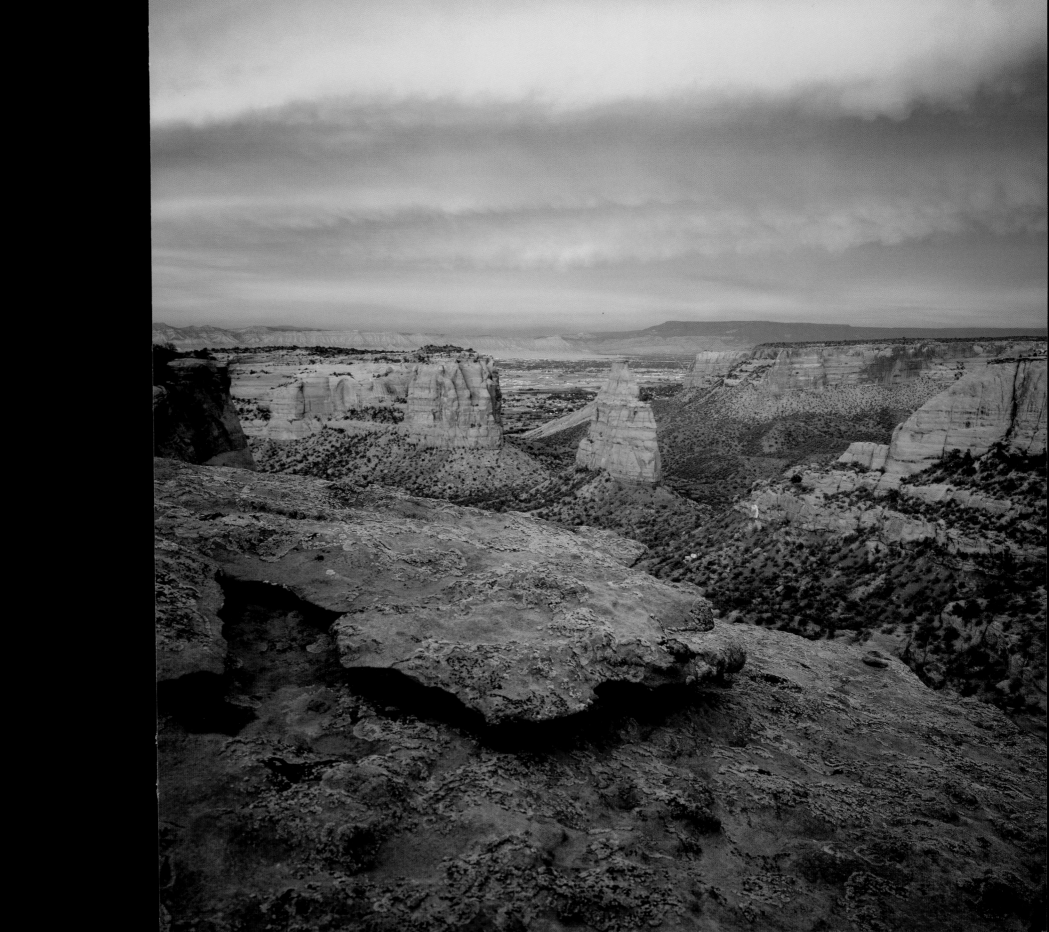

▲ Asters and columbine dot the landscape.
► Columbine even flourishes amid outcrops of lichen-
covered boulders in the Ice Lake area above timberline.
Vermilion Peak is on the western skyline.

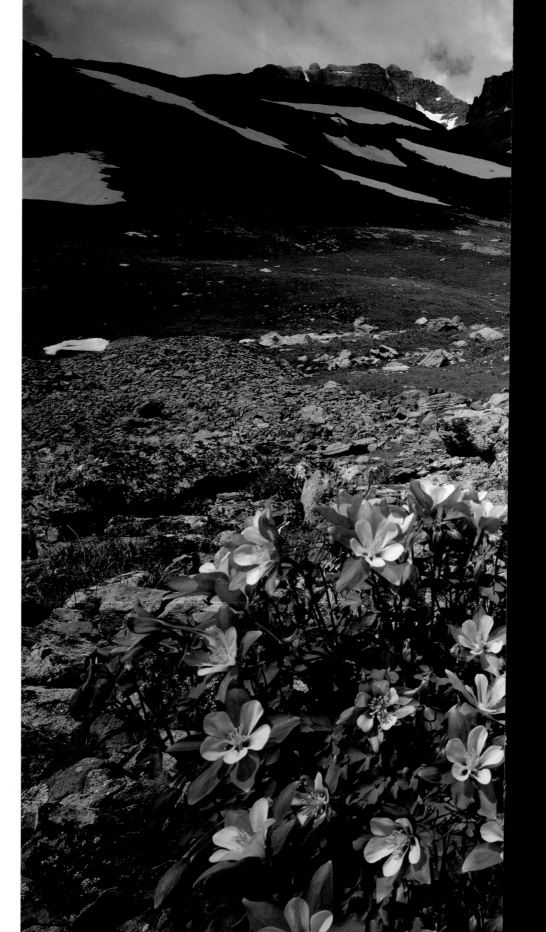

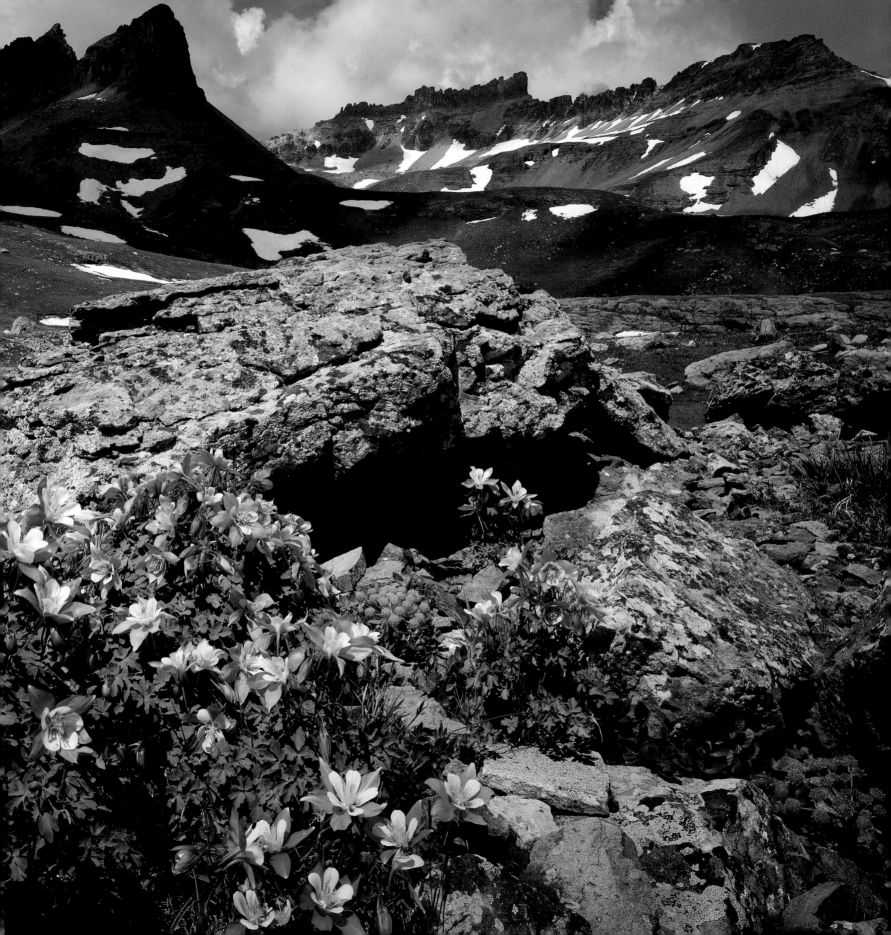

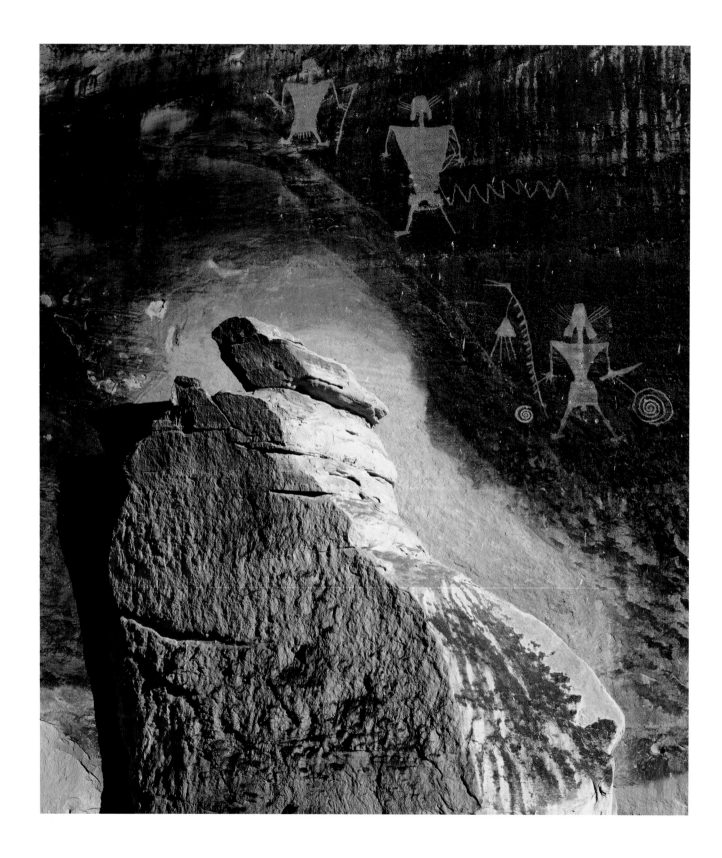

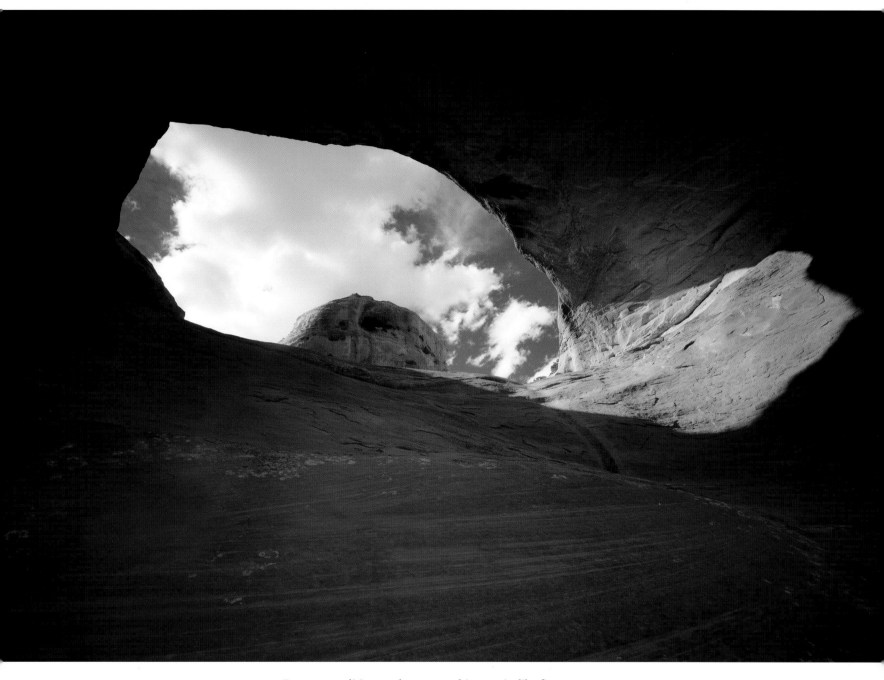

◄ Fremont tradition, anthropomorphic, warriorlike figures are
carved into a sandstone façade in Glades Park on the Uncompahgre Plateau.
▲ A window to the sky in the Rattlesnake BLM Wild and Scenic Area
is part of a sandstone rim grouping of arches adjacent
to Colorado National Monument, above Fruita.

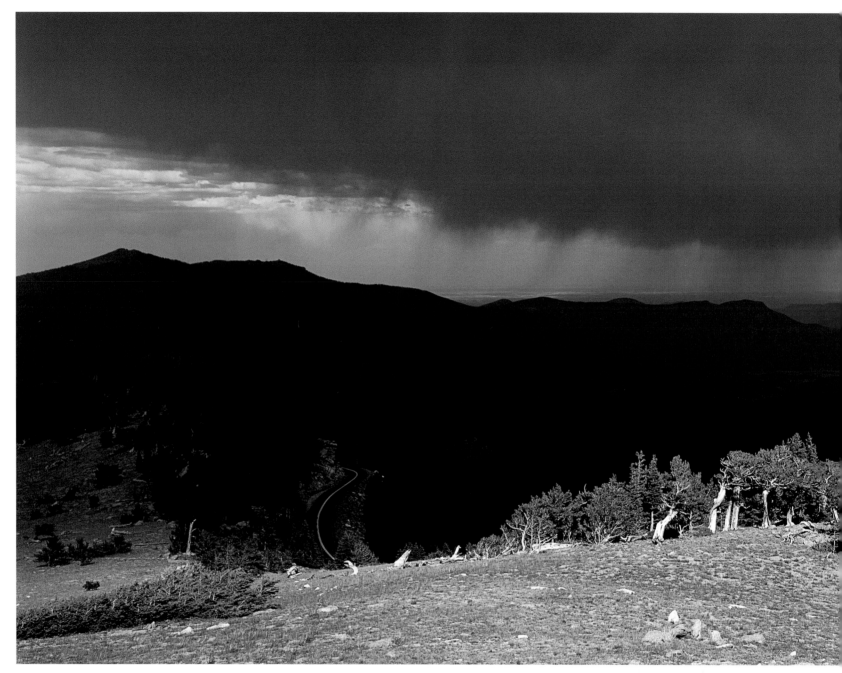

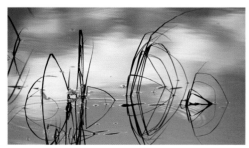

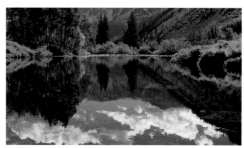

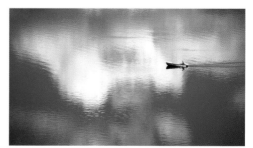

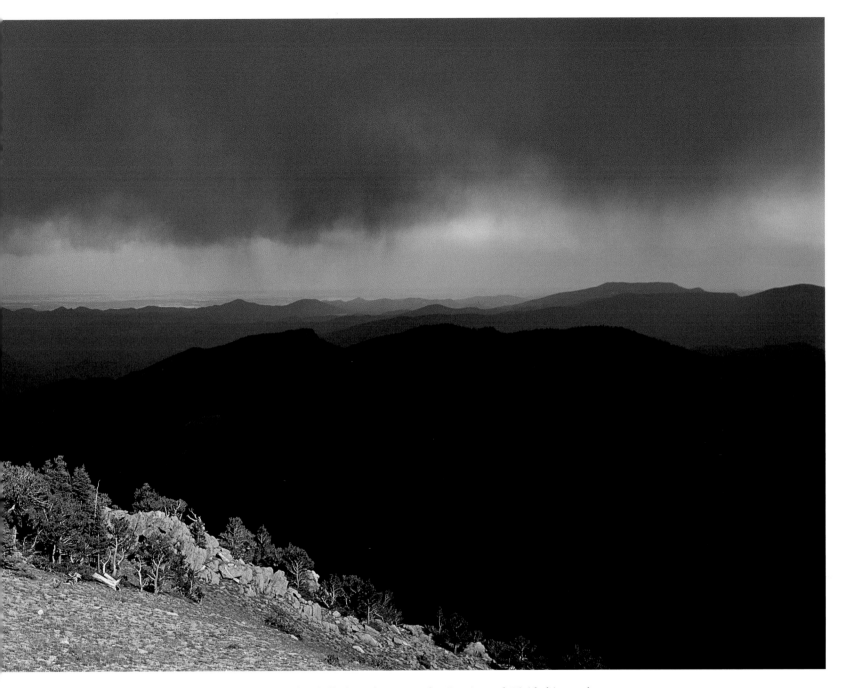

◄ and ▲ (All photos) Because the Continental Divide bisects the
state, some of Colorado's rivers eventually empty out
into the Pacific Ocean; some, into the Atlantic.

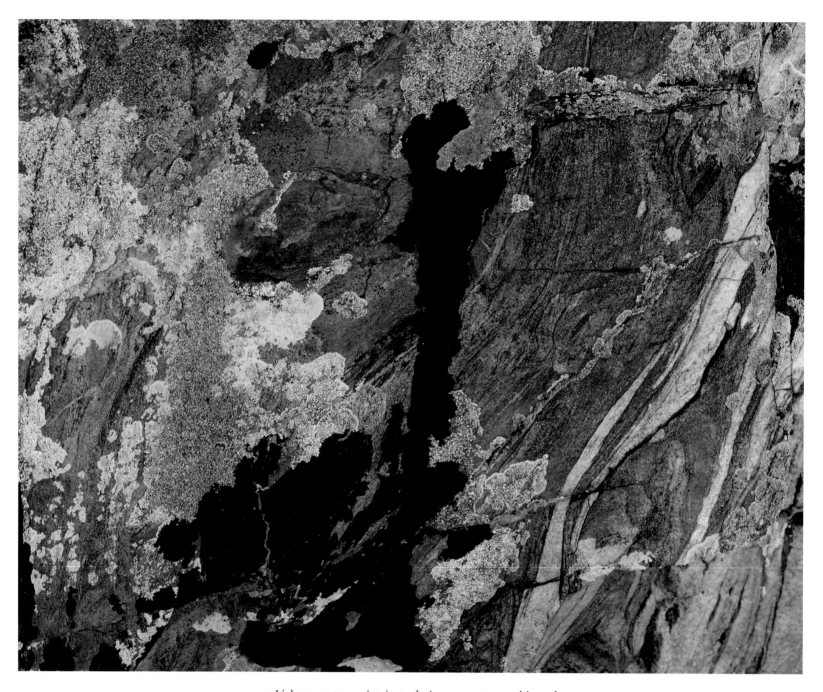

▲ Lichen creates an intricate design on metamorphic rock
on the North Rim of Black Canyon of the Gunnison National Park.
▶ Cliff rose hangs on a sandstone rim in Colorado National Monument.

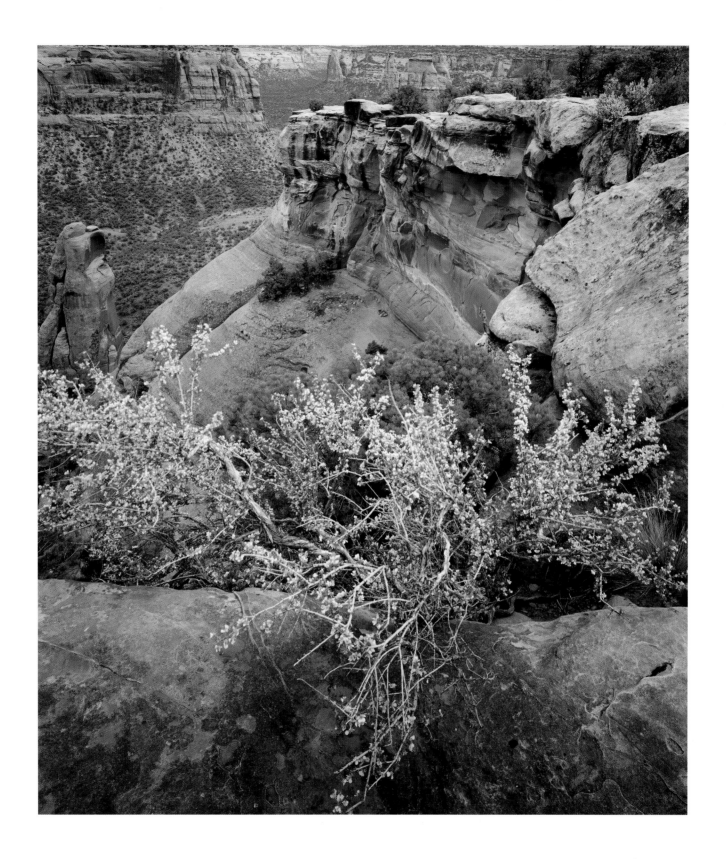

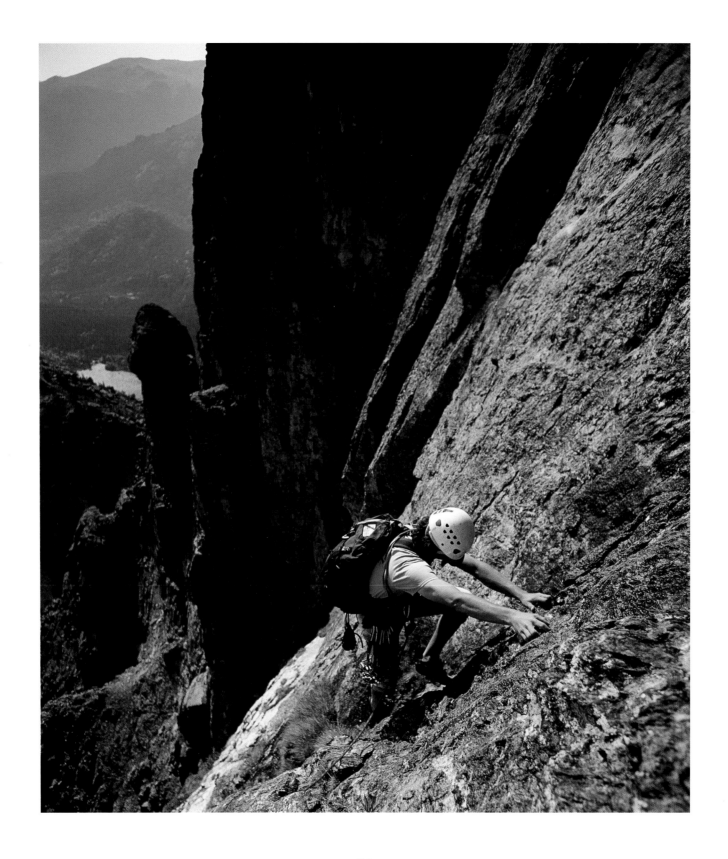

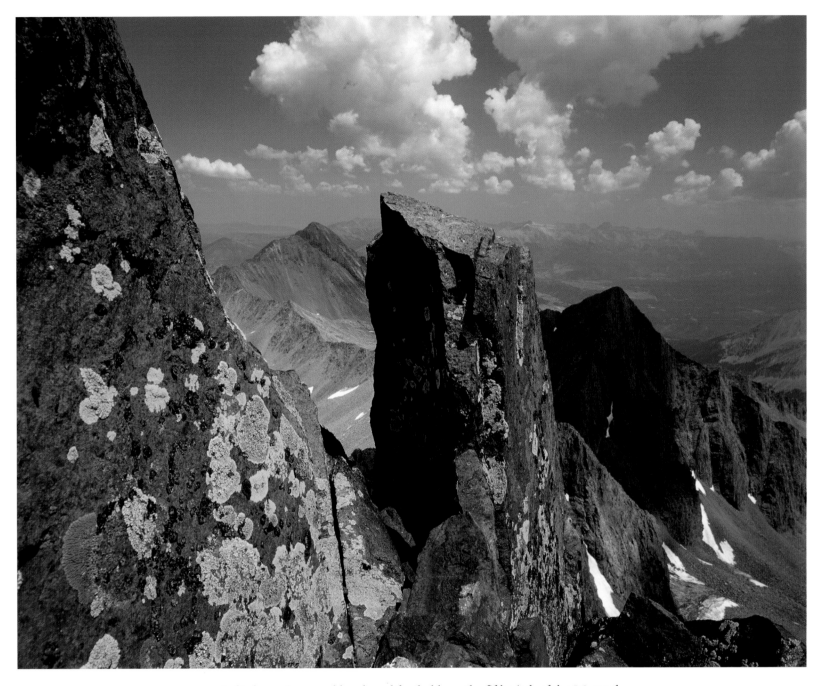

◄ A climber enjoys good hand- and footholds on the fifth pitch of the 5.9-rated
East Face Route of Hallett Peak in Rocky Mountain National Park.
▲ Lichen-painted rocks cover the summit of 14,246-foot
Mount Wilson in the San Miguel Range.

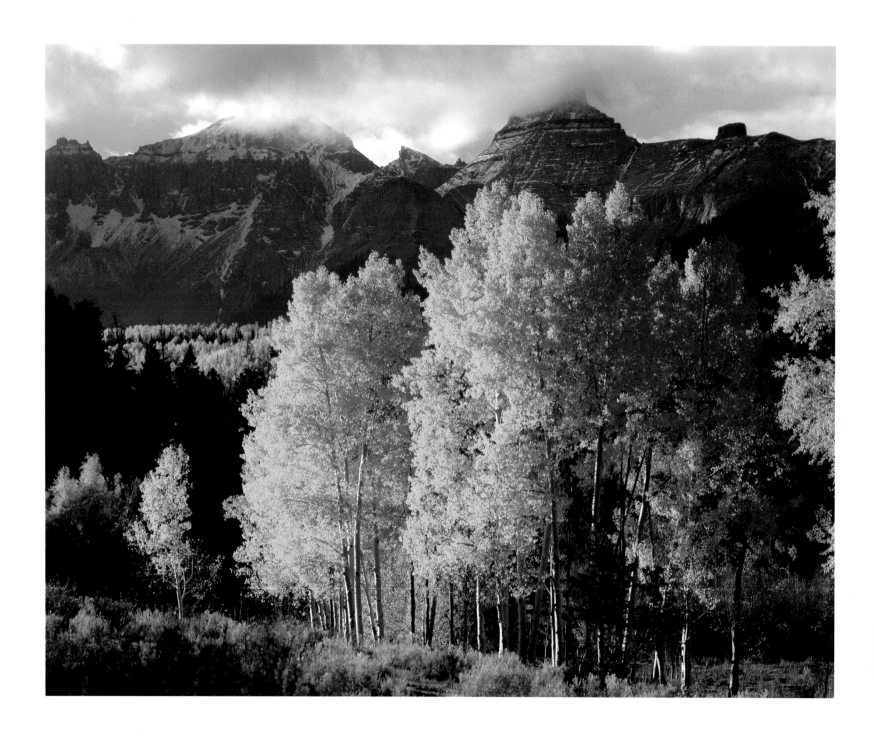

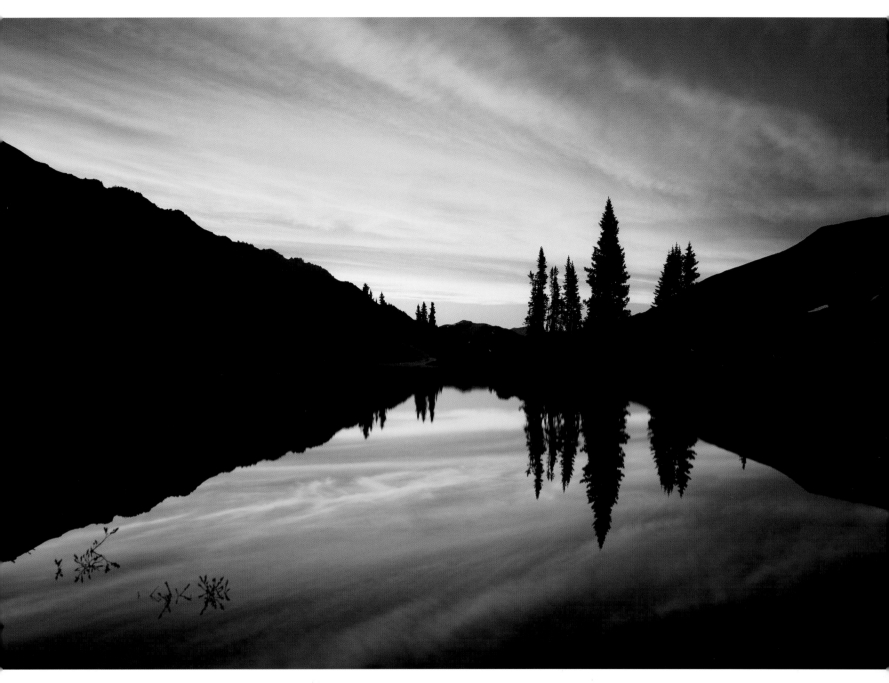

◄ Aspens display their full autumn
color before 13,819-foot Teakettle Mountain and
13,786-foot Potosi Mountain, peaks in the Sneffels Range.
▲ After thunderstorms depart late in the afternoon, a moment
of light turns the high clouds red over Paradise Basin.

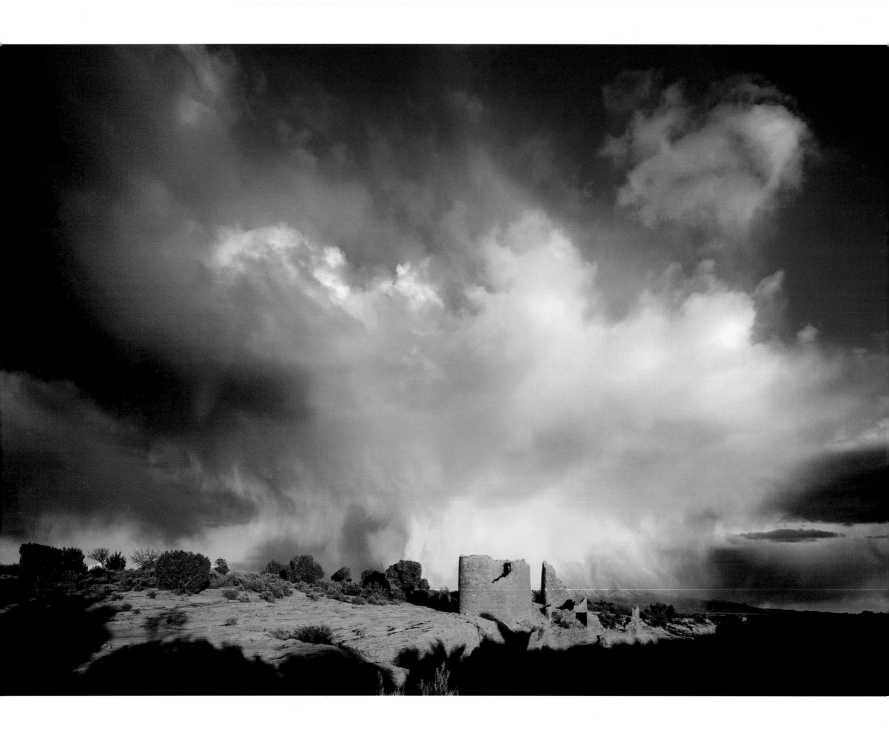

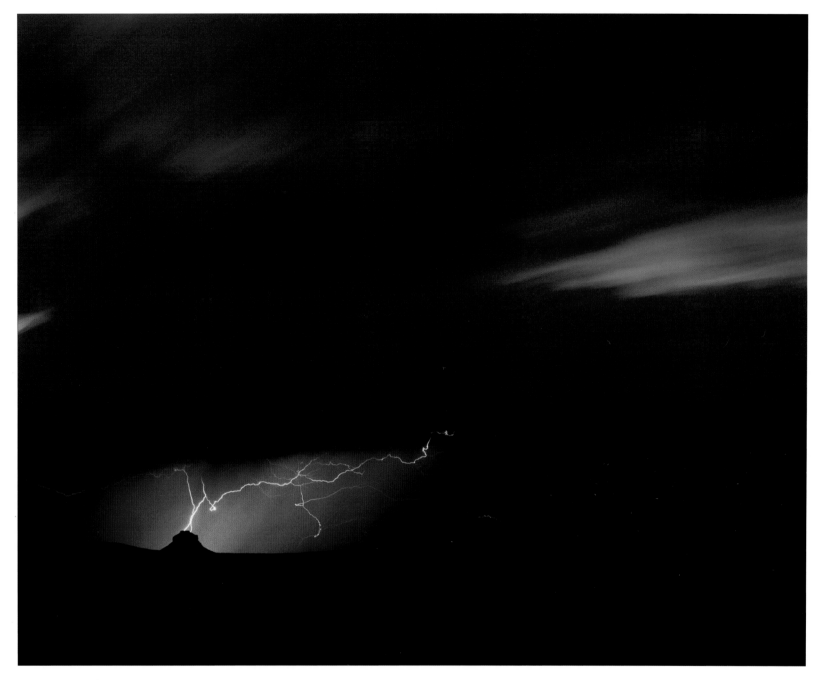

◄ An evening storm passes over Hovenweep Castle, an Ancestral
Puebloan site in Hovenweep National Monument on the Utah border.
▲ Lightning strikes the Pawnee Buttes during a passing summer thunderstorm.

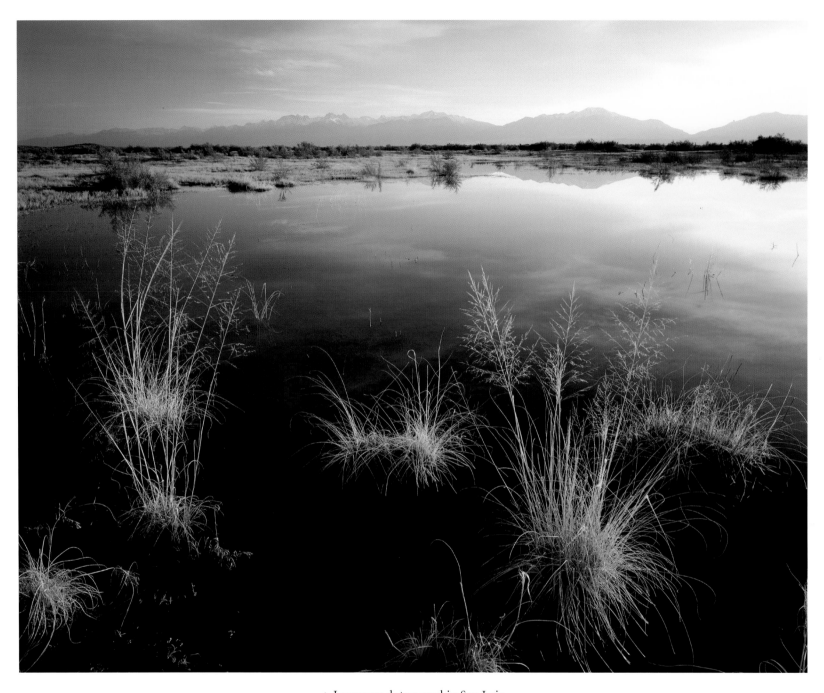

▲ Lovegrass dots a pool in San Luis
Lakes State Park, in the Sangre de Cristo Range.
▶ A stand of aspens glows in the warm afternoon light of
fall, near the headwaters to the Rito Blanco River.
▶ ▶ The sun rises through towering aspens
high on the slopes of Nipple Mountain in
the South San Juan Wilderness.

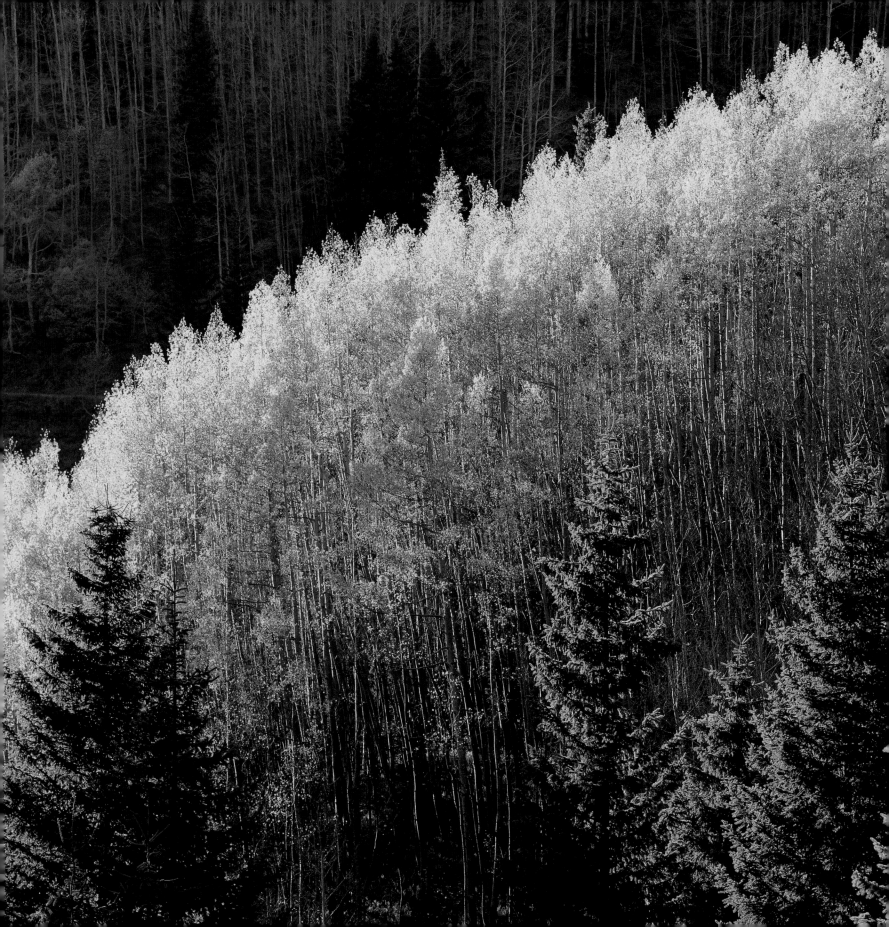

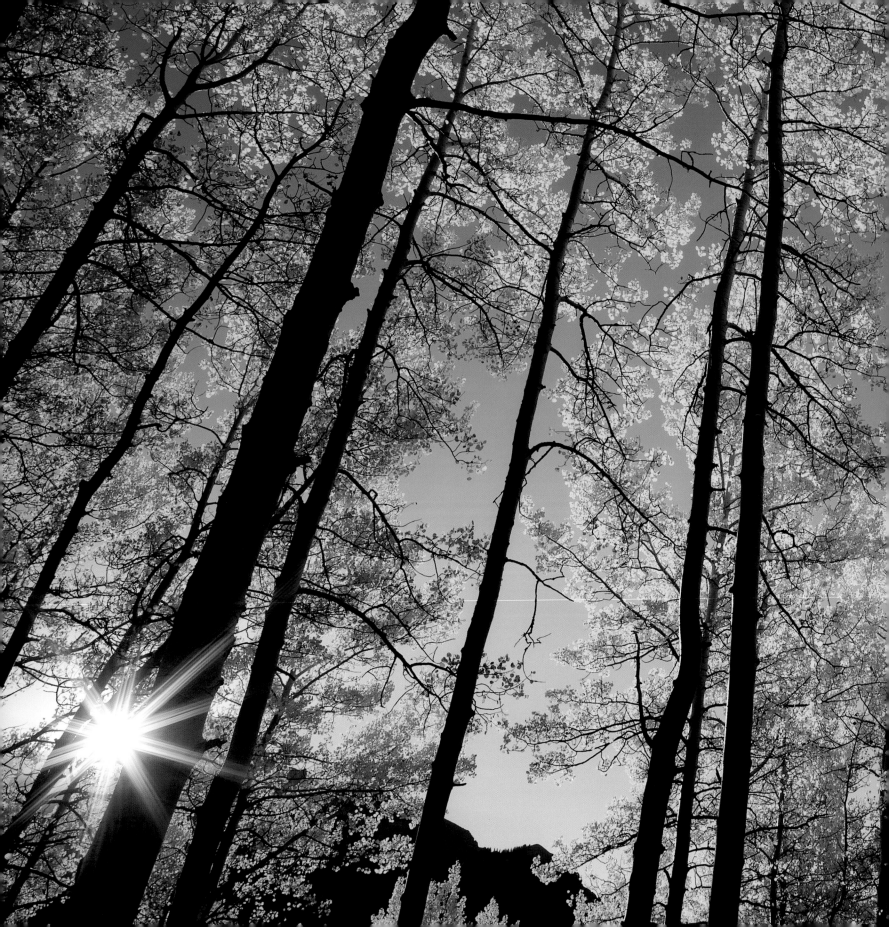

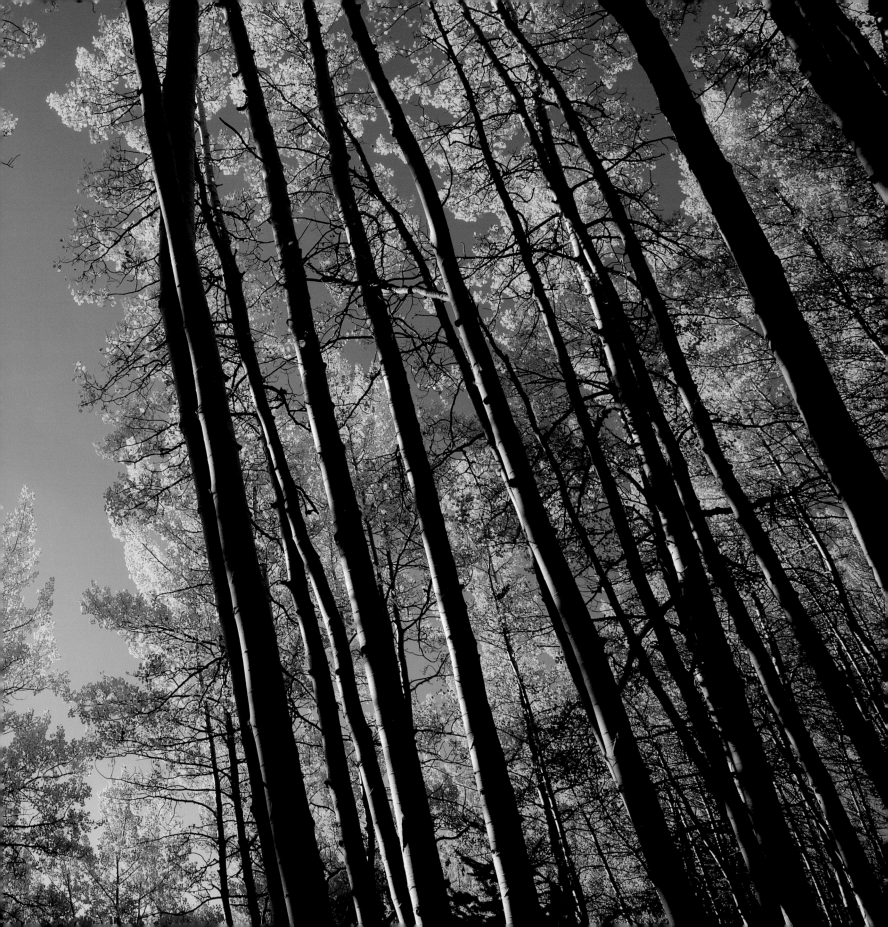

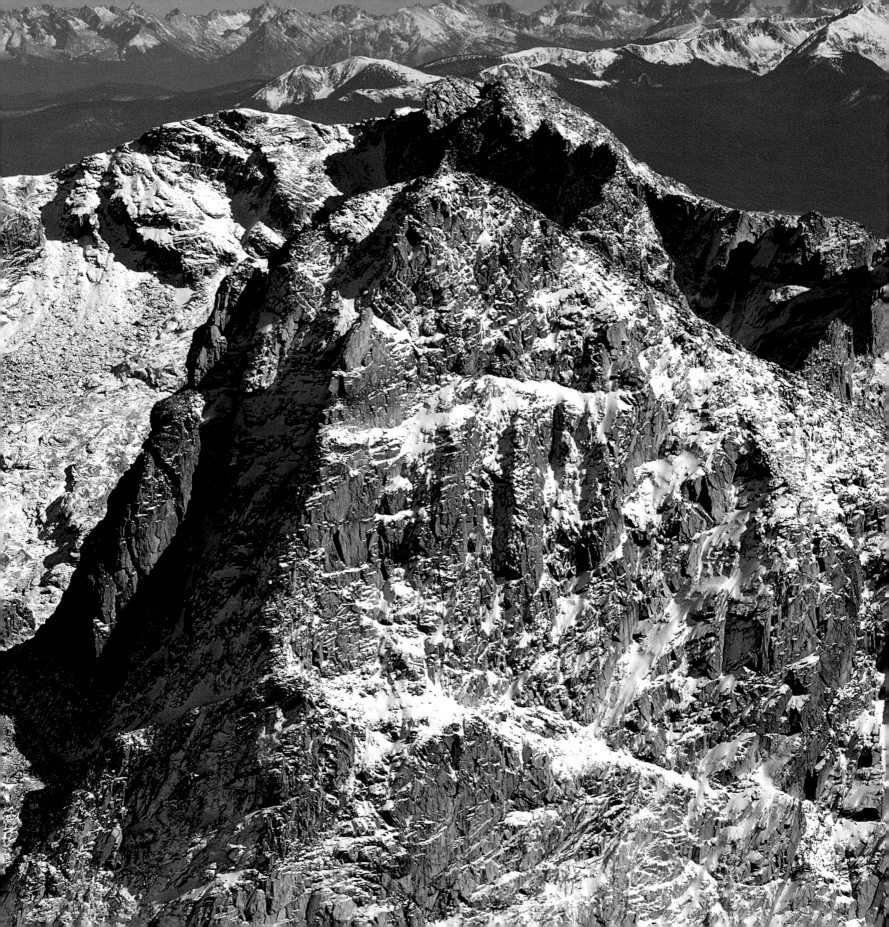

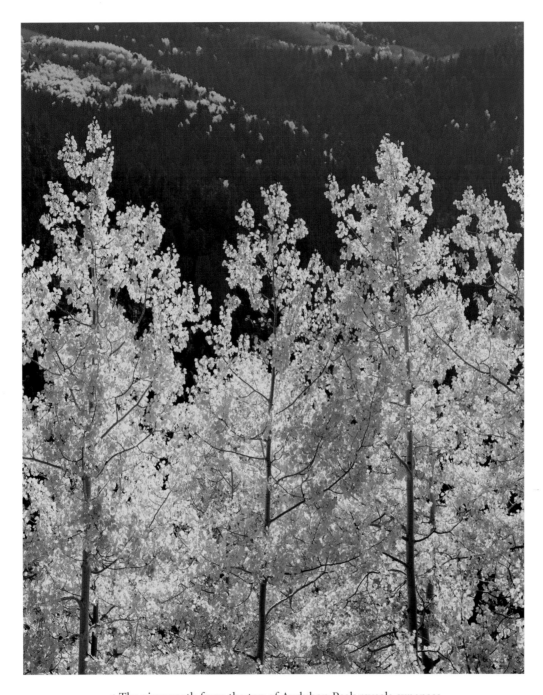

◄ The view north from the top of Audubon Peak reveals expanses
of Indian Peaks Wilderness, part of the Roosevelt National Forest.
▲ Aspens turn the banks of Wolf Creek gold in early October. Wolf Creek
drains the western aspect of the 10,850-foot Wolf Creek Pass.

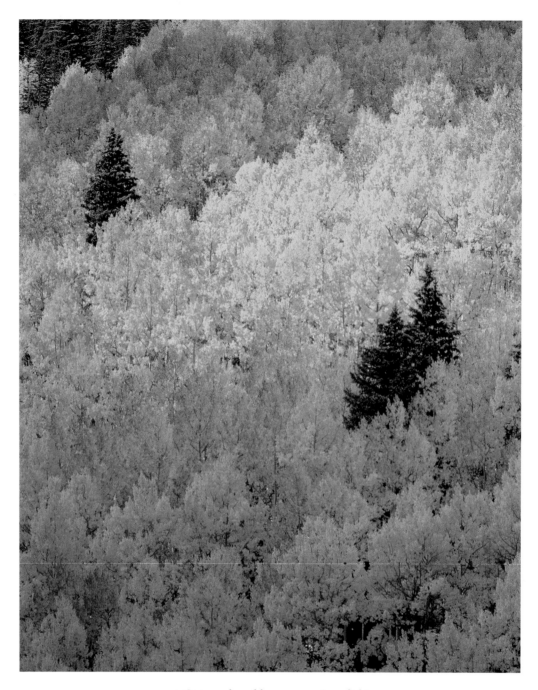

▲ Outnumbered by aspens, pines fight
for sunlight at 10,000 feet in the Dallas Divide.
► Low, swirling clouds part for a moment of sun during an
early winter storm as it passes over the western
slopes of the Sneffels Range.

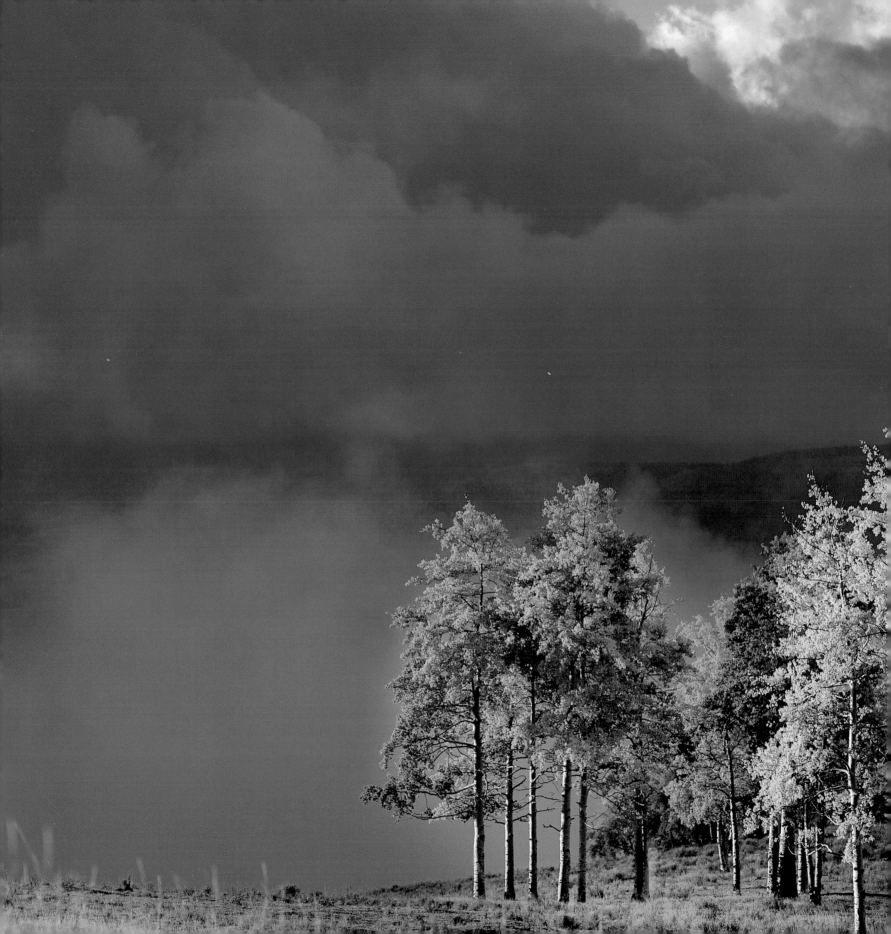

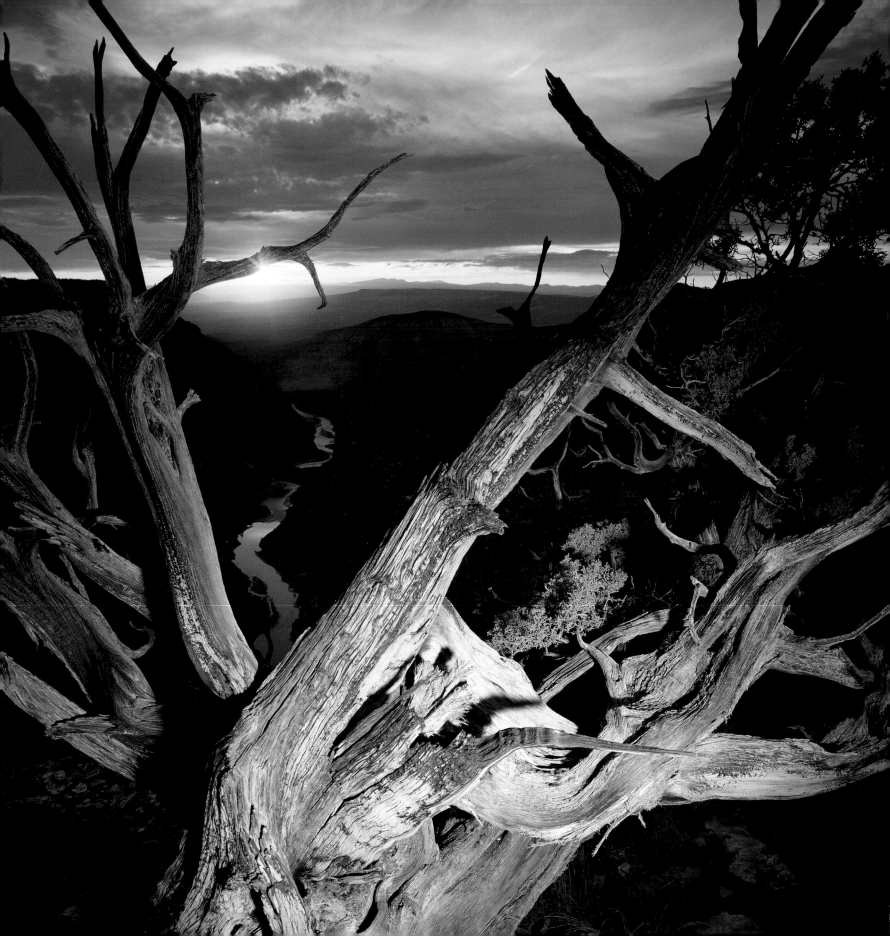

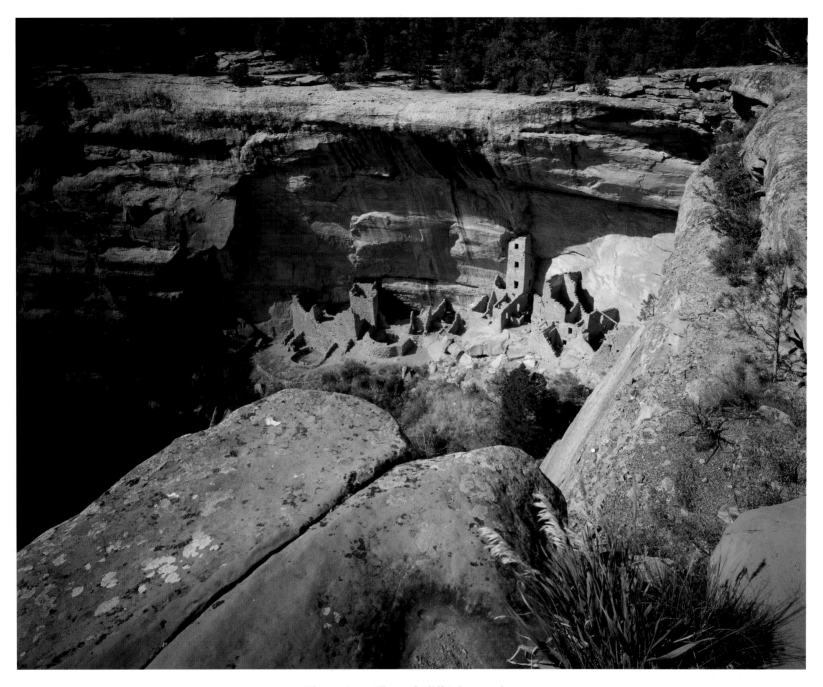

◀ The ancient village of Cliff Palace catches an
evening glow. This bird's-eye view is from the sandstone rim
of Mesa Verde Formation, Chapin Mesa, in Mesa Verde National Park.
▲ Juniper, *Juniperus,* maintains its tenacious hold on life on the limestone rim
at Harpers Corner. Below, the Green River flows southward toward the
confluence with the Colorado River in Canyonlands National Park.

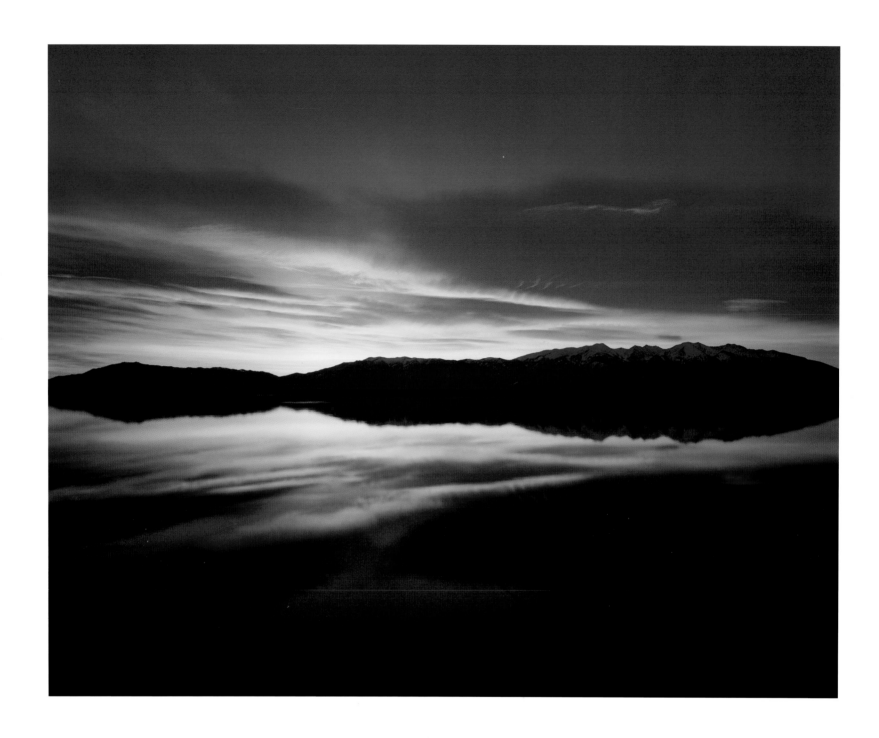

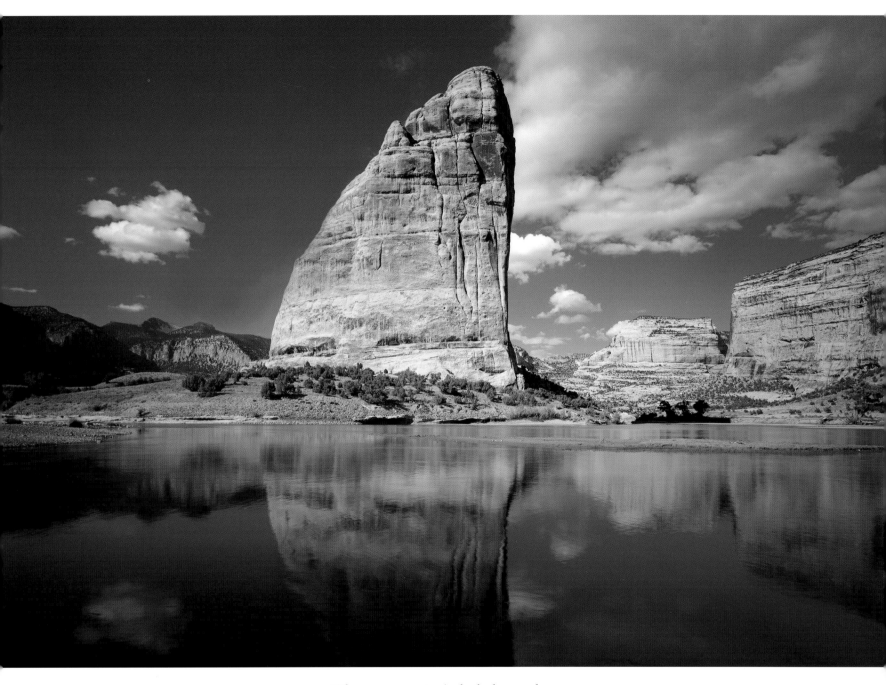

◄ The sun appears to rise both above and
below the Sierra Blanca in San Luis Lakes State Park.
▲ The Green River holds the reflection of Steamboat Rock
in Echo Park, Dinosaur National Monument.

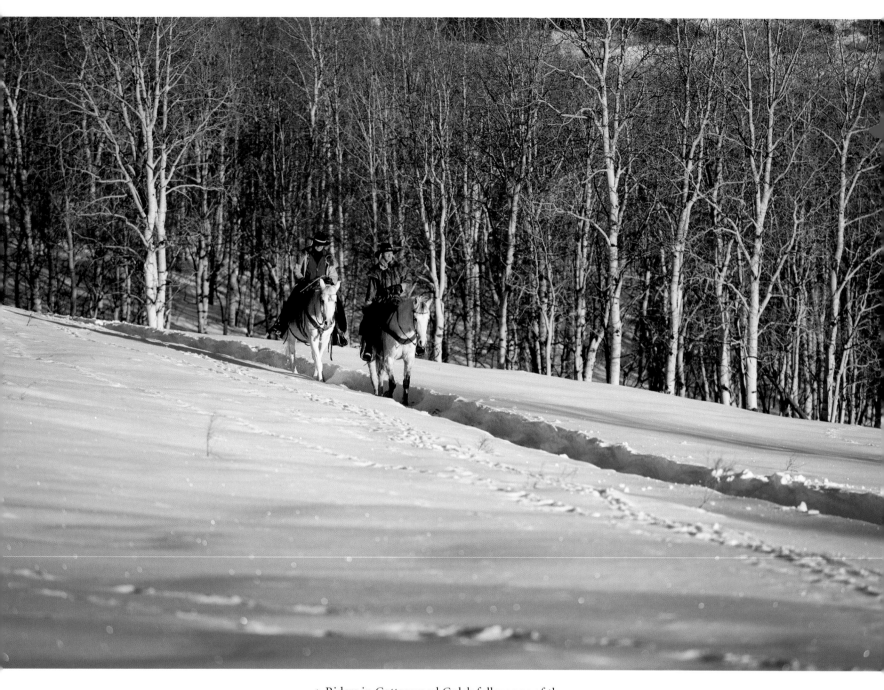

▲ Riders in Cottonwood Gulch follow one of the many
trails through the Routt National Forest in northern Colorado.
▶ The Yampa River Valley provides nutrient-rich soils that support
ranches and farms, even during the long winter months.

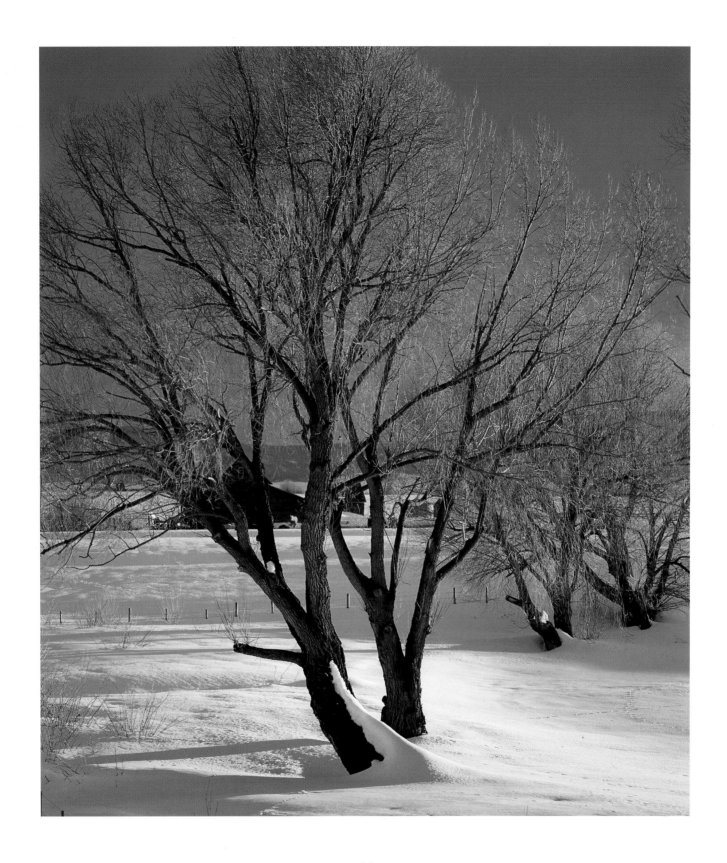

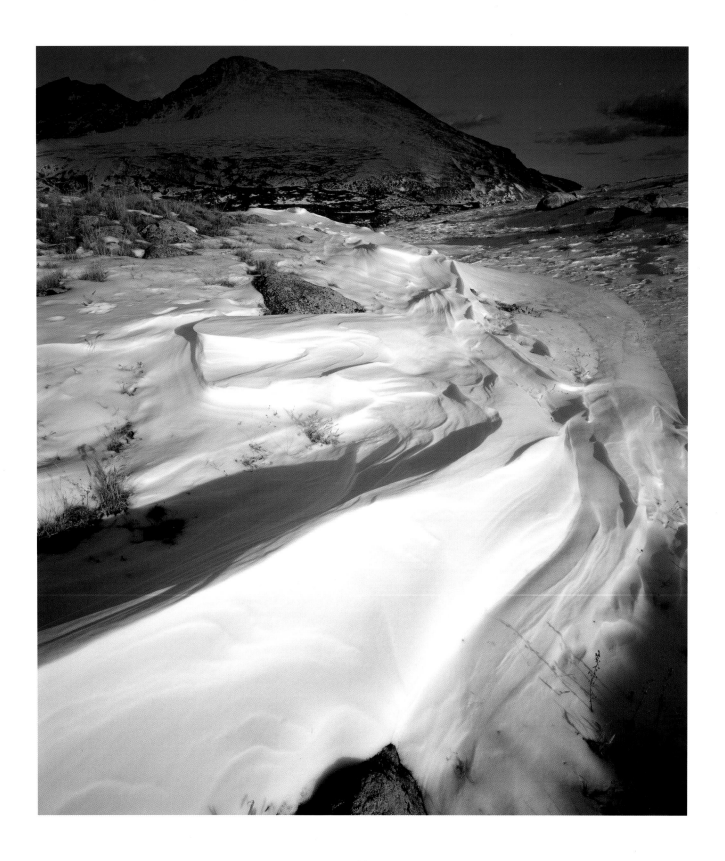

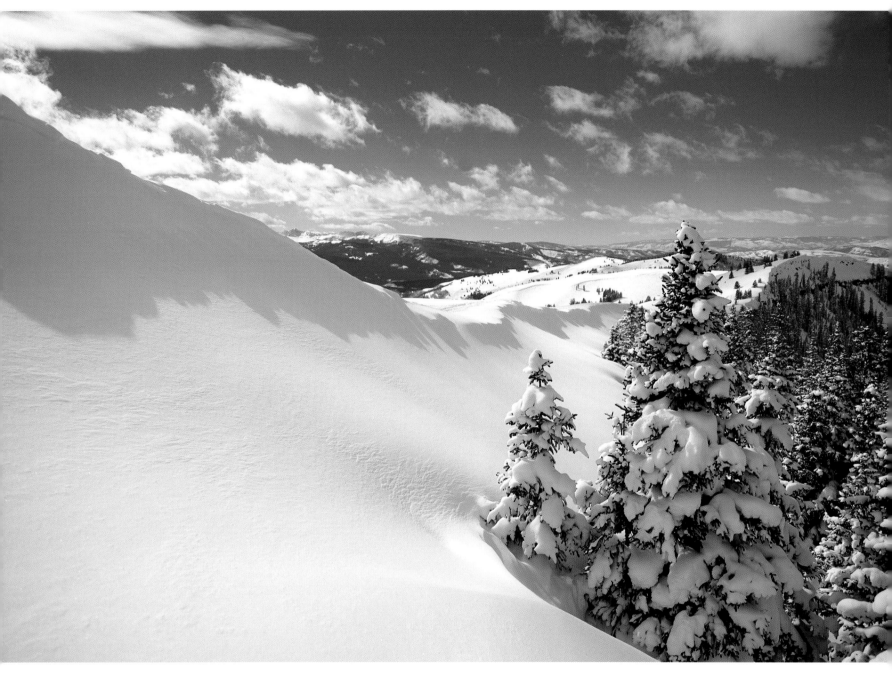

◄ Hoosier Pass, in Pike National Forest between South Park and
Breckenridge, is already buried in snowdrifts by late October.
▲ Snow-covered pines grow on the sheltered north slope
of Vail's large, rolling, summit ridge. The Holy Cross
Wilderness is visible on the western horizon.

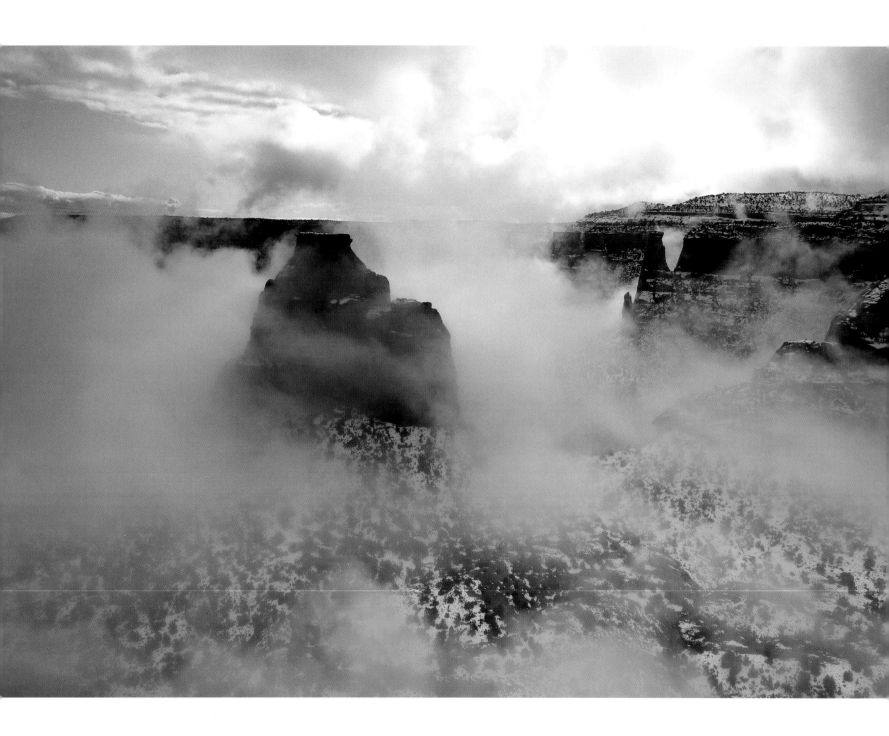

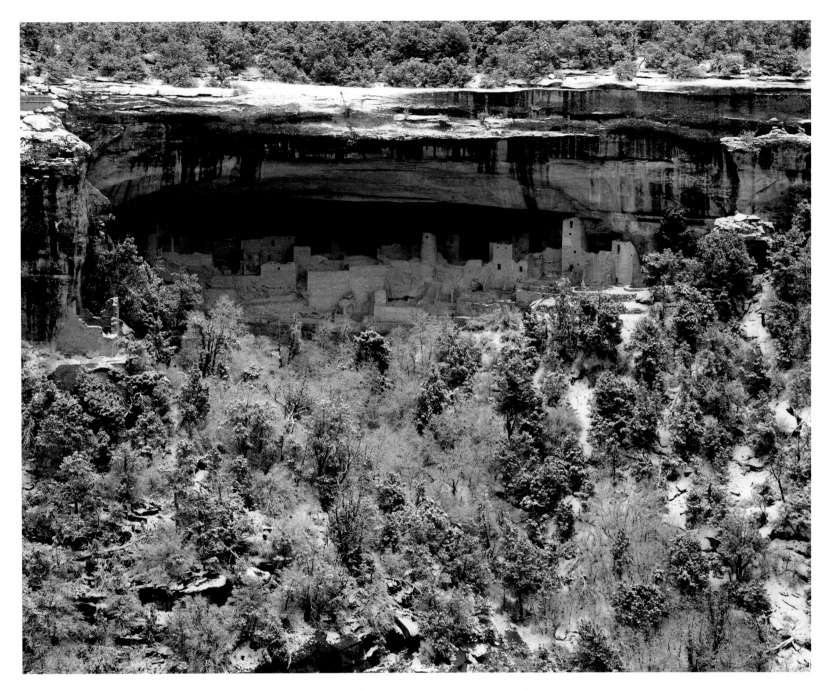

◄ Independence Monument rises ghostlike above the winter
fog in the Wedding Canyon at Colorado National Monument.
▲ A light winter snow highlights the twelfth- and thirteenth-century
cliff dwellings of Cliff Palace in Mesa Verde National Park.
►► Deep snow blankets the ranchlands of Elk Valley

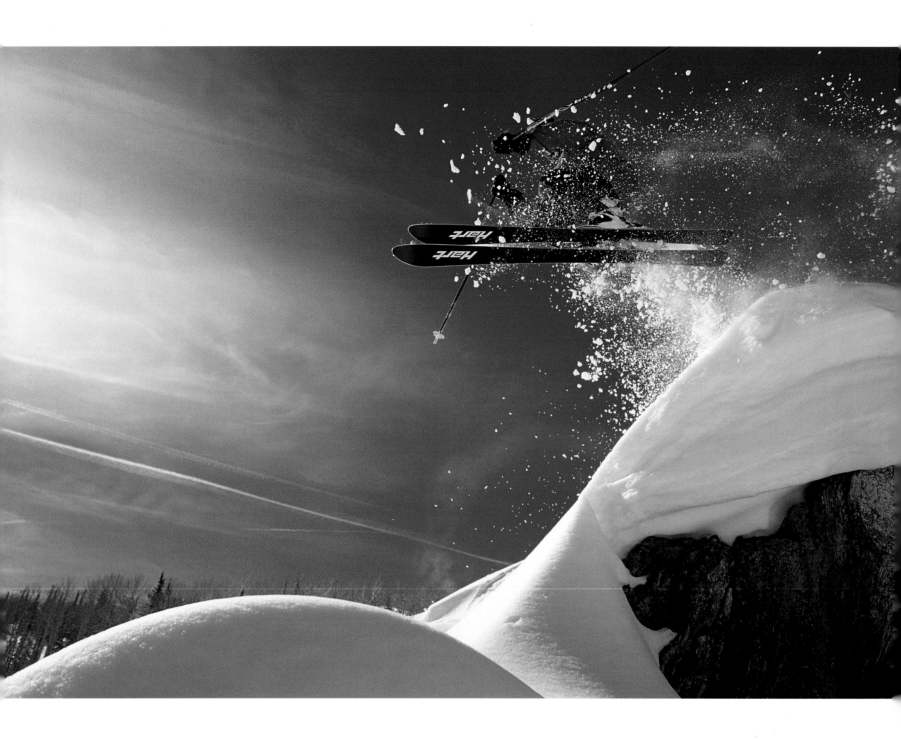

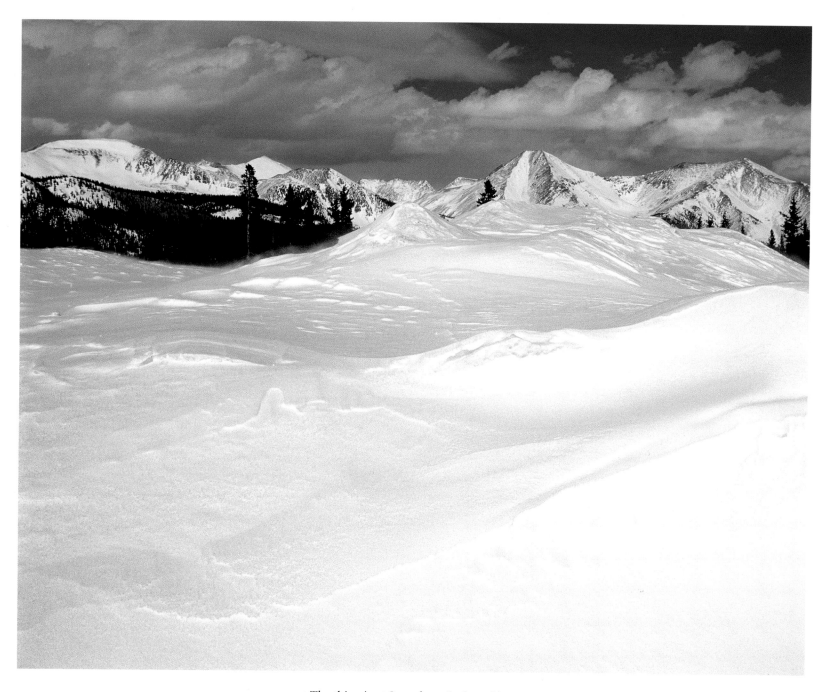

◄ The thin air at Steamboat Springs ski area
makes for easy flight. It's the landings that require
plush amounts of the soft powder "the Boat" is known for.
▲ Snowdrifts in Monarch Pass lead the way to 13,743-foot Mount
Aetna and 14,229-foot Mount Shavano in the Sawatch Range.
►► Strong north winds pile up a large cornice at the
top of the Copper Mountain ski area.

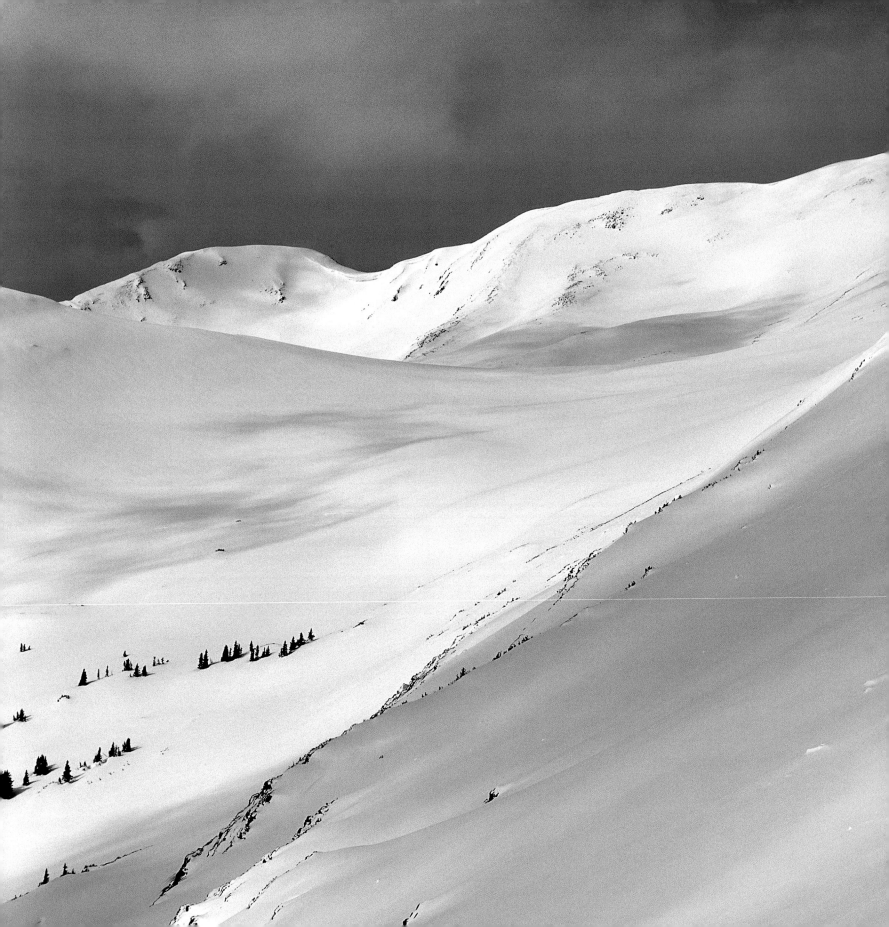

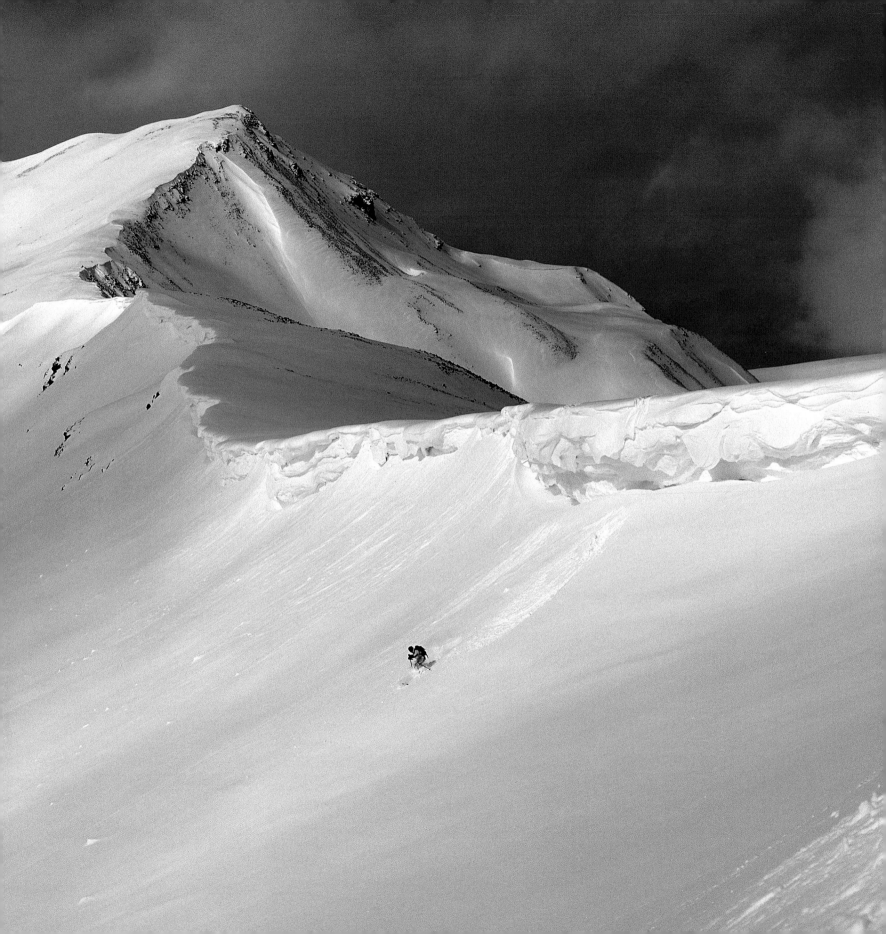

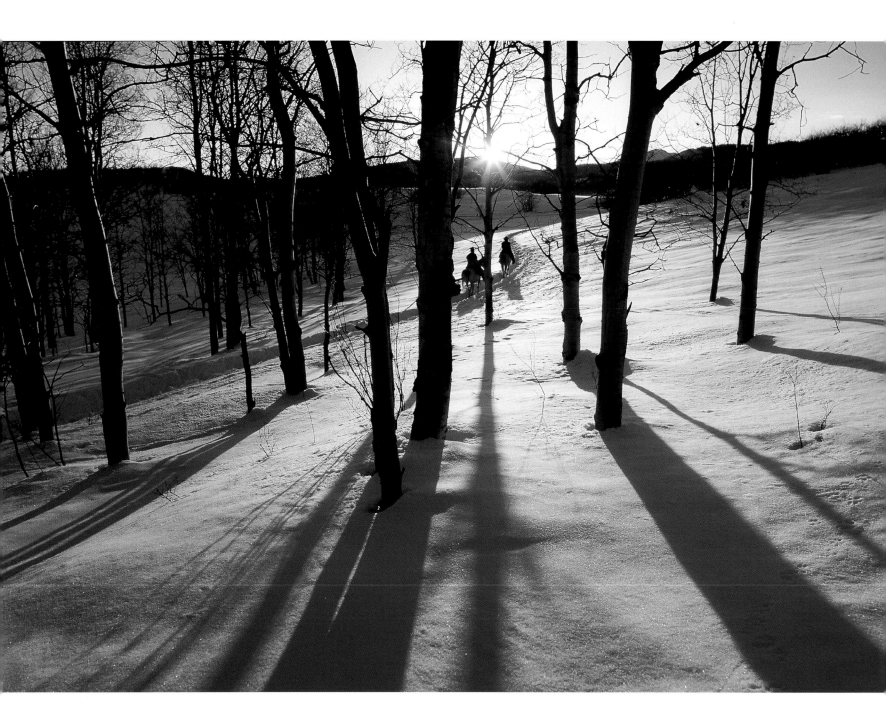

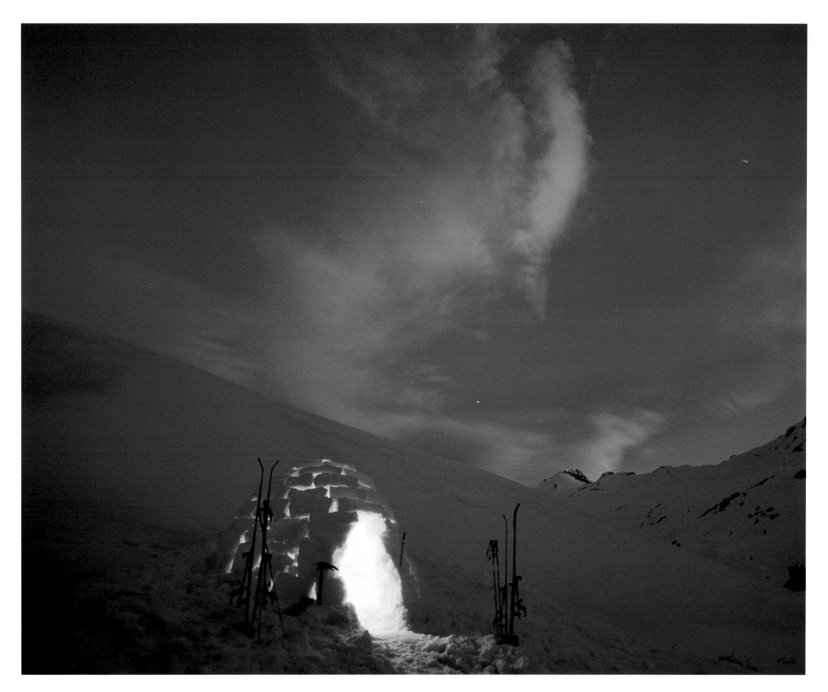

◄ Riders enjoy the warm colors of
sunset on a cold trail near the Elk River.
▲ An igloo provides a bit of shelter during a cold
night high in the Conundrum Basin.

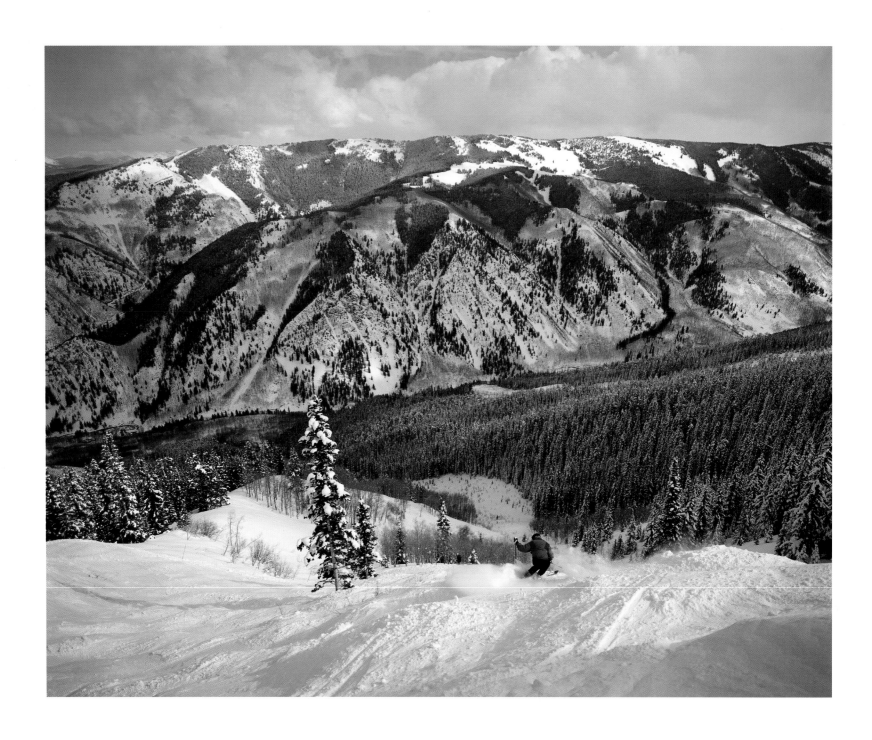

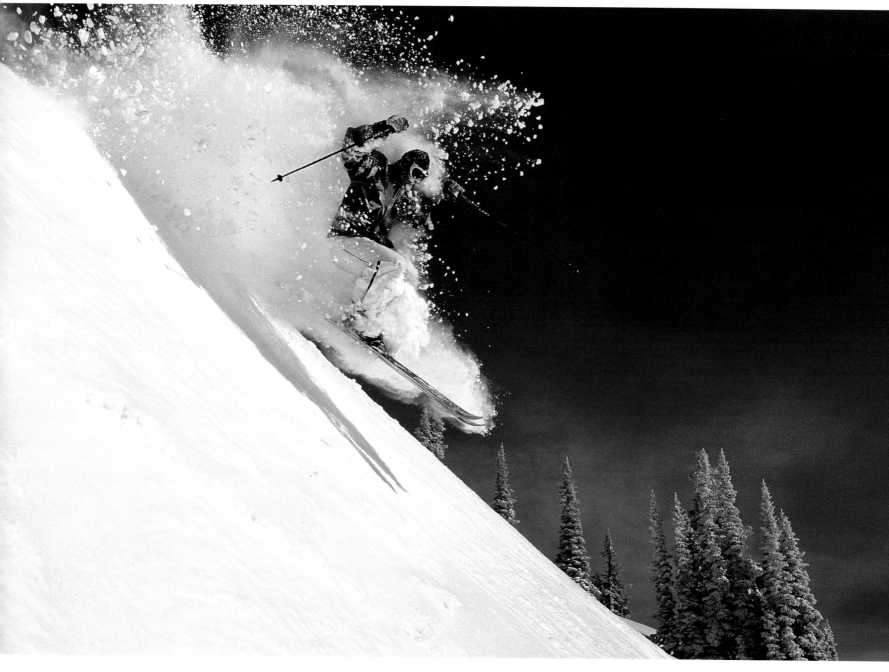

◄ On the east side of the Highlands ski area are giant,
soft moguls with steep and dramatic views of Castle Creek Canyon.
▲ A skier gets a face full of snow on Morningside ski run
off Steamboat Springs Storm Peak.

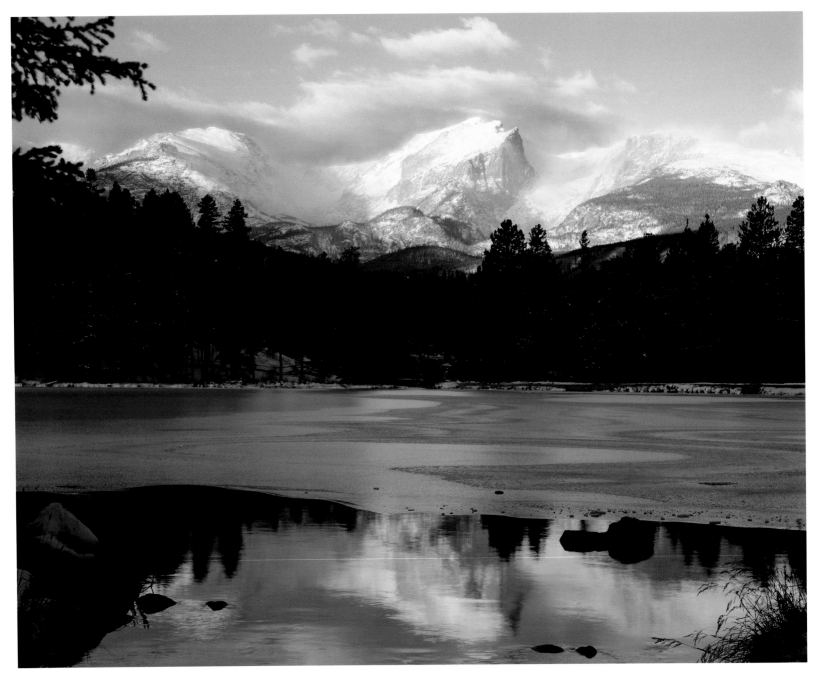

▲ Hallett Peak and ridge rise above iced
reflections on Sprague Lake in Rocky Mountain National Park.
▶ "Nacho" is one of many secret runs in Copper Bowl at Copper Mountain ski area.
▶ ▶ An early December morning reveals expanses of snow along the Hermosa
Cliffs, with Engineer Mountain visible through the spruce.

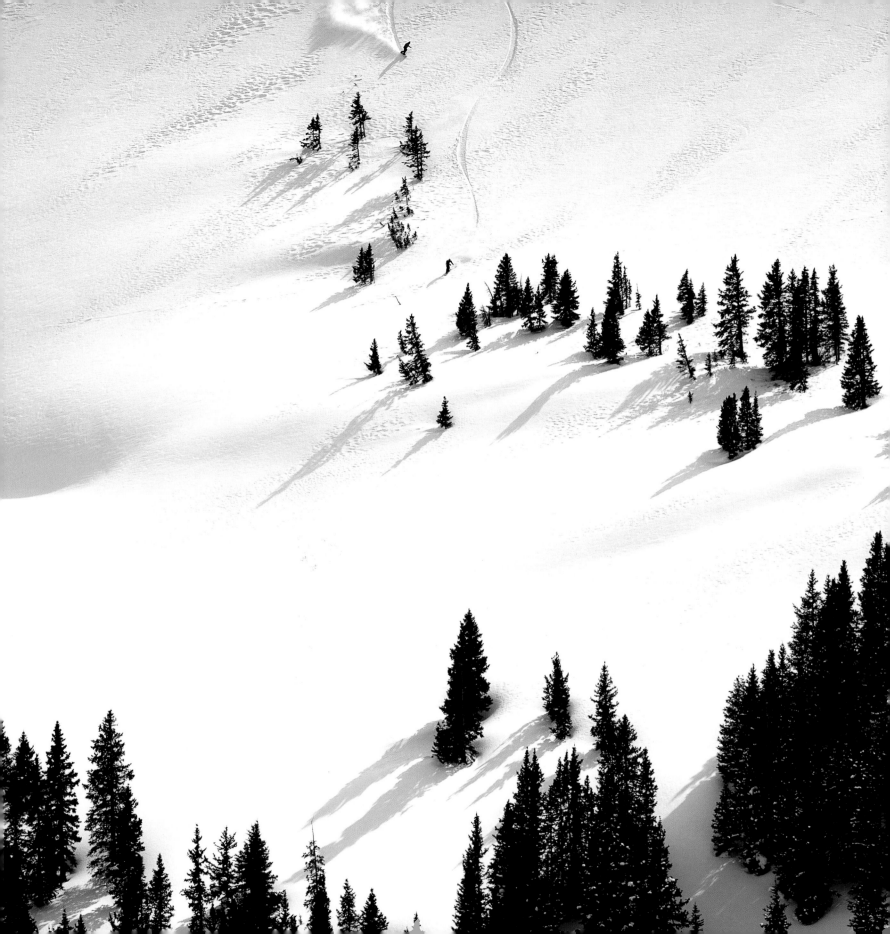

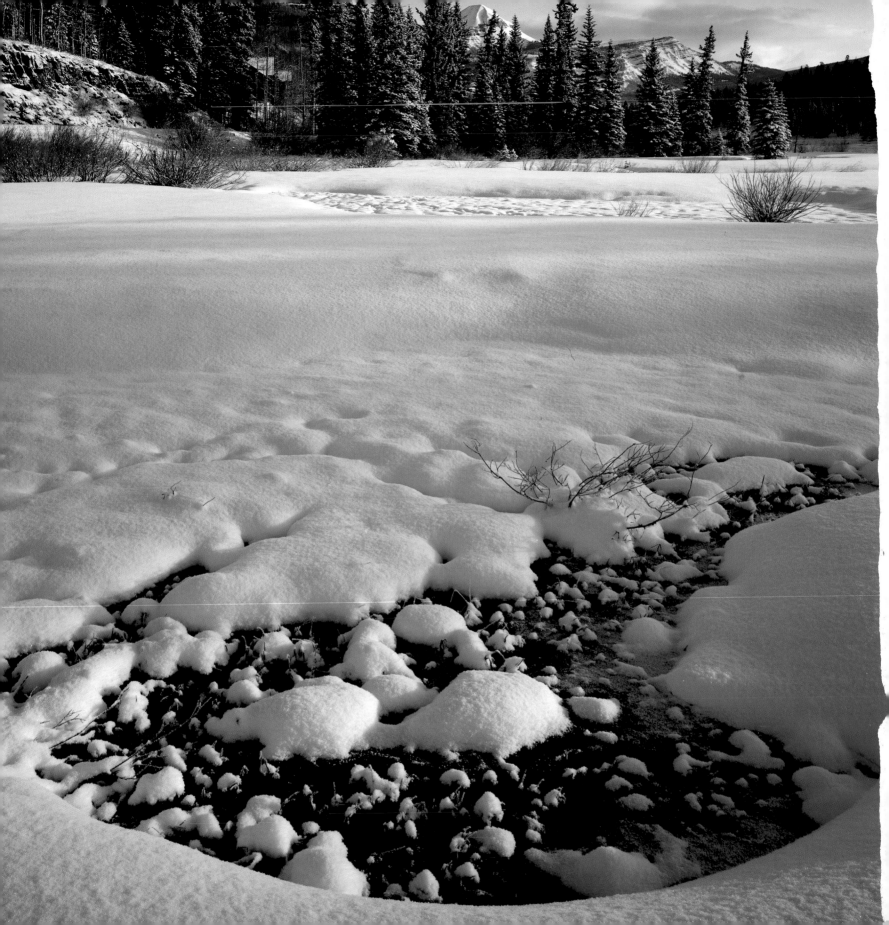